— CLASSIC —
CAROLINA
ROAD TRIPS
— FROM COLUMBIA —

HISTORIC DESTINATIONS & NATURAL WONDERS

TOM POLAND

THE
History
PRESS

Published by The History Press
Charleston, SC 29403
www.historypress.net

Front cover, bottom: The Angel Oak. *Courtesy of Brad Ferguson.*

All photographs courtesy of the author unless otherwise noted.

First published 2014

Manufactured in the United States

ISBN 978.1.62619.650.6

Library of Congress Cataloging-in-Publication Data

Poland, Thomas M., 1949-
Classic Carolina road trips from Columbia : historic destinations and natural wonders /
Tom Poland.
pages cm
Summary: "Vignettes about all the sites in SC one can visit in a day trip from Columbia"--
Provided by publisher.
Includes bibliographical references.
ISBN 978-1-62619-650-6 (paperback)
1. Columbia Region (S.C.)--Tours. 2. Columbia Region (S.C.)--Description and travel.
3. Historic sites--South Carolina--Columbia Region--Guidebooks. 4. Natural areas--South
Carolina--Columbia Region--Guidebooks. 5. South Carolina--Tours. 6. South Carolina--
Description and travel. 7. South Carolina--History, Local. I. Title.
F279.C7P65 2014
975.7'71--dc23
2014027030

To the next generation of day-trippers: Ben, Connor, Harper, Katie, Mary Beth and Will

CONTENTS

A HOP, SKIP AND A JUMP
Day Trips 51 to 100 Miles Away

JUST AROUND THE CORNER
Day Trips 50 Miles or Less

ACKNOWLEDGEMENTS

I thank Barbara Ball of the *Independent Voice* in Winnsboro, who asked me to write day-trip features for her. I also thank my coauthor of *Reflections of South Carolina* and *Reflections of South Carolina* Volume 2, Robert Clark. We often travel together on assignment, and when we do, I take my camera with me. Much of what we document turns into day trips.

THE CLASSIC AMERICAN ROAD TRIP—BEFORE YOU GO

Make sure your vehicle is road ready. Check all fluid levels and the pressure in your tires. Don't forget to make sure the spare tire is good to go. Clean your vehicle; it makes a drive go so much better.

While GPS devices are great, take a map. When you need it most is when technology fails.

Pack along some water and healthy snacks. You won't find many restaurants along back roads.

Have no deadlines. Take your time and enjoy the journey, for the back roads themselves make for a fine destination.

Take good photos and write your day trip experiences in a log.

Expect the unexpected, for traveling the back roads is pure adventure.

STRIKE OUT AND EXPLORE

While a certain cachet comes with saying you've traveled to Venice, Paris and other fashionable venues, it's surprising how many historic places are within driving range. In the course of writing seven books about South Carolina, I've been to spots and secret places with appeal all their own, and I've learned something: you don't have to go abroad to experience marvelous places, nor do you need to flock to the clichéd "must see" venues. Rustic beauty, natural areas, history and interesting sights and places surround the Midlands.

Living in the Midlands, in fact, puts you in an ideal place to strike out and explore South Carolina. Few cities have three interstates running through them. An interstate can quickly take you to more interesting byways that course through the heart and soul of South Carolina. For instance, take I-20 and head east toward Camden, where you can take side roads that lead to Highway 261, the Kings Highway. Travel that tree-shaded lane, and you follow the footsteps of two armies, including a famous Civil War diarist who lived along its shoulders.

Much awaits discovery. When I pick up a map of South Carolina, I don't see colored lines and legends. I see artisans who craft beautiful and useful things. I see waterfalls and raging whitewater. I see oaks of legend, a covered bridge, a drive-in theater and North America's only tea plantation. I see vanquished civilizations, forgotten monuments, abandoned dreams and evidence of man's passion for conquering—and then abandoning—his surroundings. If you like Rome's ruins, you will love Old Sheldon Church,

Glendale, the St. Helena Chapel of Ease and Fort Fremont. Curious about the land your forbears knew? Then go back in time to see what this country looked like before we cut, dug and burned so much of it. Visit our national wildlife refuges and one national park.

I see nature in all its glory. Geology blessed South Carolina with mountains, rivers, beaches, plains and mysterious wetlands known as Carolina bays.

I see a culture that overflows with beauty, thanks to artists, sculptors, basket makers, potters and long-gone European stonemasons who graced the state with the products of their imaginations.

Seeking adventure? Would you like to say you've walked the state at sea level and stood on its rooftop? Well, you can.

To explore is to take back roads. Those familiar with my work will tell you I appreciate interstates as a speedy way to get from point A to B, but no one takes a journey on an interstate. Whenever you can, take the back roads. Take a highway like Highway 261, where a historical marker greets travelers: "Over it came Indians, pack animals laden with hides, drovers, rolled hogsheads of produce, wagoners, and stagecoaches." Now that's the kind of road I want to travel.

Journey Highway 76, a road that crosses the entire state. As it winds and dips its way from North Carolina toward Georgia, here's what you'll come away with: "Highway 76, once a mere line on a map, now lives in your mind. You can place your finger on 76's thread-like presence and know that here hangs a deer head, here lies a sunken gunboat, and here is great fried chicken."

The best thing about day trips is that you can avoid the crowd. You won't find yourself surrounded by hordes that go to a place just to say they went. A day trip to Campbell's Covered Bridge, for instance, rewards you with solitude, beauty and the opportunity to explore all you want—and best of all, there's no need to stand in line.

Columbia is in a fortunate place, being located in the dead center of the state. Plan your day trips and strike out with a camera, a GPS device and a desire to explore. Adventure is just around the corner, so much so that you can postpone that trip to Rome's ruins. We've got ruins of our own.

<p style="text-align:center">***</p>

Any book like this one needs to be accompanied with a caveat. Places close. Hours, fees and services change or vanish, but it's never been easier to get updated details. Check ahead to be sure your adventures go as planned.

One final note—I'm using the address of the South Carolina State House (1100 Gervais Street, Columbia, SC, 29201) as a central point for estimating time and distance to venues. Depending on where you live, you can estimate your time and distance or MapQuest it. Strike out and explore historic destinations and natural wonders.

Happy adventuring!

MAKE IT AN OVERNIGHTER

Day Trips 151 or More Miles Away

A DANCE KINGDOM

S outh Carolina's beaches are popular, especially in the summer, but one beach is popular year-round. A 160-mile drive will take you to a town that was and is an icon. Once known as Ocean Drive or "OD," North Myrtle Beach is the epicenter of all things shag and beach music. Thousands return to North Myrtle Beach in the fall, winter and spring to shag and share good times and memories.

Now, you don't have to be a shagger to enjoy a journey to this dance kingdom. If you recall or are just plain curious about the good old days of open-air pavilions, cars with fins, snow cones, glowing Wurlitzers, R&B music and lifeguards, you'll enjoy a trip to North Myrtle Beach.

The shag was *the* dance along the Grand Strand in the late 1940s and early 1950s—a memorable time of classic cars, ice cream sodas, cold beer and nights afire with love. Many would look back on this golden era as the apex of youth and romance. It was a glamorous, chivalrous time. As evening fell, the lights of open-air pavilions beckoned. As gleaming lines of surf broke outside pavilions and clubs, couples danced. Neon Wurlitzers and Rock-Olas gobbled change. Shaggers danced along the leading edge of a pop culture revolution in places indelibly etched in memories: the Myrtle Beach Pavilion, Sonny's Pavilion, Spivey's, Robert's Pavilion and cramped "jump joints."

Ocean Drive assumed iconic stature. Lifeguards were bronzed gods. Women were sun-kissed "peaches" to be plucked by men with perfect dance-floor cool. There was nothing like an evening of club hopping, and

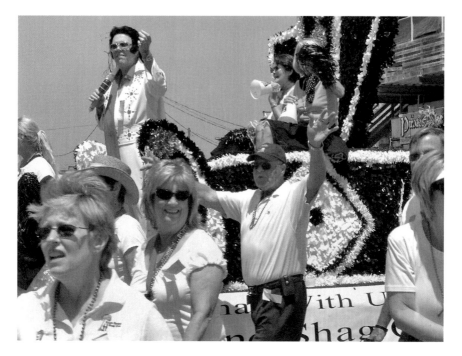

The colorful SOS Spring Safari delights onlookers.

the shabbier they were, the better. Ask shaggers about OD. If you tell them you're going, they'll want to hitch a ride with you. They'll regale you with stories of OD and culture-shocking times.

Back in OD's heyday, young people were the original rebels, and their hangouts were the iconic pavilions. The pavilions were ordinary but exalted. In the early 1980s, Melissa Williams of the *Greenville Piedmont* described Spivey's Pavilion as "a ramshackle, tattle-tale gray, paint-chipped pavilion. It was an old haunt where people carved their names in wooden booths overlooking the dance floor. It was their domain, where engulfed by friends, their music, and their self-designed lifestyle, they could revel in rebellion."

All the old pavilions are gone, but you can recapture this wonderful time, a bit of Americana and, for certain, a South Carolina legend by making the trip to North Myrtle Beach. You'll see plenty of men wearing penny loafers, and old classic beach tunes will mingle with the salt air to take you back in time. You'll be at the Grand Strand, so there's no way you'll hurt for restaurants and things to do. Pack a bag because you might decide to stay overnight.

(This column consists of excerpts from *Save the Last Dance for Me: A Love Story of the Shag and the Society of Stranders*, written by Tom Poland and Phil Sawyer and published by University of South Carolina Press, 2012.)

If you go, visit:

FAT HAROLD'S BEACH CLUB
www.fatharolds.com

BEACH MEMORIES
www.beachmemoriesart.com

OD PAVILION
www.odpavilion.net

BROOKGREEN GARDENS

About three hours away in Brookgreen Gardens, you'll find the world's largest collection of outdoor sculpture (1,444 statues) in one of the Southeast's most beautiful public gardens. Brookgreen Gardens is a major destination near Murrells Inlet, where you can find plenty of fine seafood restaurants when your statue gazing is done. Myrtle Beach is close by as well. For sure, there is plenty to do on this 158-mile day trip.

In the beginning, the sprawling site where Brookgreen sits was part of four rice plantations. One of those plantations, Brookgreen, bequeathed its name to the gardens. The thousands of acres in Brookgreen's Lowcountry History and Wildlife Preserve are rich with native plants and animals of the South Carolina Lowcountry. You'll see evidence of the great rice plantations of the 1800s, too.

Archer M. Huntington was the stepson of railroad magnate Collis Potter Huntington. Archer and his wife, Anna, a noted sculptor, purchased the four rice plantations (9,100 acres) as a site for showcasing sculptures. The location provided a more temperate refuge for Anna Huntington, who suffered from tuberculosis from the mid-1920s to the mid-1930s. She and Archer would go on to found Brookgreen Gardens. They built a winter home, *Atalaya*, Spanish for "watchtower." Archer Huntington, a noted Spanish culture expert, designed the house after the Moorish architecture of the Spanish Mediterranean coast. A square tower, which housed a three-thousand-gallon cypress water tank, rises about forty feet over the structure. Architecture of this type is rare in the United States. As you'd expect, it is listed on National Register of Historic Places.

Founded in 1931 as the nation's first sculpture garden, Brookgreen is home to an abundance of statues. See, for instance, Gleb W. Derujinsky's *Samson and the Lion*, which he sculpted in 1949 and was placed in Brookgreen Gardens the following year. Note how the play of light on the stone brings realism to this work, which depicts Samson as a force of nature. The statute stands at the center of a reflecting pool.

Another popular statue is *Diana*, which stands in the middle of a circular pool as jets of water pay homage to the goddess. Augustus Saint-Gaudens sculpted *Diana*. One of America's greatest artists, his work is exhibited around the world. He became an American when his French father and Irish mother brought him to New York after his 1848 birth in Dublin.

Visit Brookgreen Gardens' website and check out its "Events" page. From January to March 6 on Sundays, Tuesdays and Thursdays at 12:00 p.m. and 2:30 p.m., you can reserve a ride on the Trekker, a safari-like van, down back roads and explore cemeteries, Brookgreen's "silent cities." Walk through former slave and plantation owner graveyards and learn about the historical burial customs of European and African origin. Tickets are fifteen dollars in addition to garden admission for this two-hour excursion.

If you go:

BROOKGREEN GARDENS
1931 Brookgreen Garden Drive
Pawleys Island, SC 29585
843-235-6000
www.brookgreen.org

OCONEE STATION
HISTORIC SITE

See the Majesty of Falling Water

Each March 1, a destination with history and natural allure opens. Get some comfortable walking shoes and a stout hiking stick and head to the northwest corner of the state. In one trip, you'll see eighteenth- and nineteenth-century South Carolina while enjoying spring wildflowers, cool air, low humidity and stunning mountain vistas covered in splendid shades of new-leaf green. Rocks, water and nature—it's all here.

You'll see an old military compound, Oconee Station, which later became a trading post. See this solid, enduring stone blockhouse that the South Carolina State Militia used as an outpost from around 1792 to 1799. The blockhouse was built as a haven from Indian attacks. Thirty of the "hardiest and best hunters" defended the blockhouse. See, too, the nearby William Richards House.

Here you'll get a beautiful mix of history, nature and outdoor recreation. A 1.5-mile nature trail connects hikers to a trail leading into Sumter National Forest that ends at Station Cove Falls. If you like, camp at nearby Oconee State Park before summer heat and pesky insects arrive. The park has rustic CCC-era cabins and a lake with a swimming hole. You can rent a canoe and fish. Hike wooded nature trails that wind through the foothills region. These trails connect with the Foothills Trail, South Carolina's eighty-mile wilderness hike on the Blue Ridge Escarpment. One trail connects Oconee Station with Oconee State Park.

Particularly rewarding is the hike to Oconee Station Falls, also known as Station Cove Falls. I hiked it one summer afternoon, and though it seems

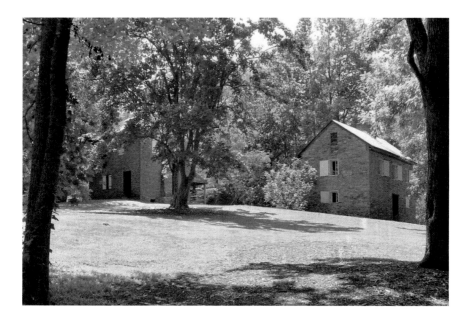

Oconee Station, a haven from Indian attacks.

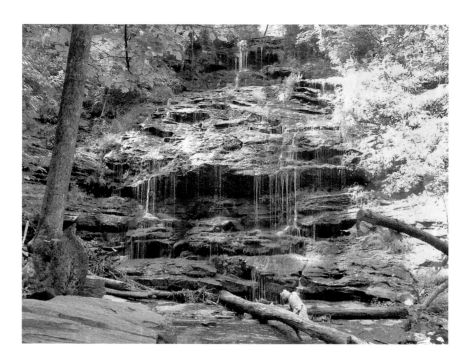

You'll be glad you made the walk to see this cascading falls.

longer than it is (.7 miles), on a hot day, the falls at the end make the effort worth it. I find Oconee Station Falls to be one of the state's more beautiful falls. The hike takes twenty-five minutes to half an hour, and as you walk, you're moving through a mountain cove forest. While crossing a sandy stream on my hike, I saw a huge paw print, and both bobcats and mountain lions crossed my mind. When you get to the falls, you can't help but stare at the sixty-foot stepped plummet. Go on a spring day. Look for wildflowers such as trillium, mayapple, pink lady's slipper orchids, bloodroot and redbud. Take a picnic lunch and relax at the boulders at the base of the falls.

About 154 miles (two hours and thirty-nine minutes) will take you to Walhalla. From Walhalla, take S.C. 183 north to S.C. 11. Take S.C. 11 north for 2 miles. Signs show the way to Oconee Station State Park. Turn left onto Oconee Station Road and follow 2 miles to Oconee Station. Revisit S.C. 11, the Cherokee Foothills Scenic Highway, which is a treat in itself.

If you go:

OCONEE STATION HISTORIC SITE

ADMISSION: Free

DAYS AND HOURS OF OPERATION:

March 1 to November 30, 9:00 a.m. to 6:00 p.m. daily
Historic structures are open from 1:00 p.m. to 5:00 p.m. Saturday to Sunday, with guided tours available.
Get more information at www.southcarolinaparks.com/oconeestation/introduction.aspx.
For information on Oconee State Park, visit www.southcarolinaparks.com/oconee/introduction.aspx.

ROAD TRIP DOWN HIGHWAY 76, LEG ONE

From Spring Branch to Mayesville

S ummer means road trips. Here's a guide to crossing South Carolina in three drives. Slung across the Palmetto State like a thin, low-hung belt and cosigning with 176, 378, 301, I-26, I-126 and other roads, 76 runs across the entirety of the Palmetto State. In all, 76 runs 548 miles, east to west, from Wrightsville Beach, North Carolina, to Chattanooga, Tennessee.

I have driven every inch of it, and I know that for those who live along its path and those who go to work on it, it flows as essential as ever. On three Sundays, I journeyed its length—past both remnants of an old South Carolina and a shiny new South Carolina. My escort? The goddess Change.

Highway 76 begins unceremoniously, easing into South Carolina from Tar Heel land. No state sign welcomes me—just a small sign heralding my arrival in the Horry County community of Spring Branch. Crossing the Little Pee Dee, I'm in vintage country. A tire swings from a tree near the Spring Branch Country Store. And then Nichols, all 1.4 square miles of it, arrives.

From a weathered mansion's column, a framed deer head stares at 76 passersby. Man's oldest calling, hunting, thrives here. And fighting, too. The town of Marion honors Revolutionary War hero Francis Marion, and just beyond flows the Great Pee Dee, the river that missed renown in Stephen Foster's "Old Folks at Home." Spying the Suwannee River on a map, Foster preferred "Swanee's" lyrical fit.

Highway 76 can be surreal. A "Broken Arrow" incident, the first, happened at Mars Bluff. A B-47, No. 876, left Savannah's Hunter Air Force Base for North Africa. At 4:19 in the afternoon of March 11, 1958, it accidentally dropped

Highway 76 enters South Carolina near Nichols.

an unarmed nuclear bomb in the woods behind Bill Gregg's home. The bomb slammed down in gummy loam, and its high-explosive trigger dug a crater fifty feet wide and thirty-five feet deep. No one died.

Not far away, a gunboat sleeps way down beneath the Pee Dee. The Confederate Mars Bluff Naval Shipyard built the CSS *Pee Dee* upriver from the 76 Bridge. Because Sherman was coming, Confederates sank the boat on March 15, 1865. Archaeologists plan to raise three of the boat's cannons from Pee Dee silt.

Fields and forests fly by until I arrive in Florence, where the Drive In Restaurant claims to have the Pee Dee's greatest fried chicken. That would please those Chick-fil-A bovines who take matters into their own hooves, as well as their famous cousin that lived here. In 1925, Secretary of Commerce Herbert Hoover visited Fred Young's dairy farm, whose Jersey, "Sensation's Mikado's Millie," set a world-champion butter-fat record.

In Timmonsville, the name "Cale Yarborough" says it all. NASCAR is racing through my mind as I approach Cartersville and pass JB's CB Shop, a reminder of the 1970s citizens band craze. Outside Mayesville, veins of tar run like rivers through 76, now a gravel reminder of Sumter County's old days. From here came Mary McLeod-Bethune, civil rights leader, unofficial advisor to Franklin Roosevelt and founder of Bethune-Cookman College in Daytona Beach, which she opened for African American girls in 1904.

If you go:

Take a camera. (Some backtracking will be necessary unless you take other routes.)

ROAD TRIP DOWN HIGHWAY 76, LEG TWO

From Sumter to Prosperity

Sumter's regal O'Donnell House commands the eye. While it was originally built circa 1840 in the Italianate style, Frank Pierce Milburn remodeled the house in 1905 in the Neo-Classical style. Once a funeral home and now a social venue, it's listed on the National Register of Historic Places. So is Sumter's restored opera house. Built in the mid-1890s, it now houses city hall offices. Stately and evocative of Europe, I wouldn't trade this classic opera house for one hundred multiplex cinemas.

West of Sumter, the highway's military character strengthens. Jets from Shaw Air Force Base's Twentieth Fighter Wing scream over Manchester Forest. Across the Wateree River, jets streak over Highway 76 from McEntire Air Base, once known as Congaree Army Airfield.

Close by stands the last old-growth bottomland forest, Congaree Swamp National Park. World-record trees take their place among redwoods and sequoias as arboreal legends. Drive, alas, past car dealerships and fast-food restaurants into Columbia on to where 76 joins I-126 near Elmwood Cemetery. Here on a bluff, the Broad River purling below, Confederate soldiers sleep.

Approaching Riverbanks Zoo, fall line rapids churn, plummet, stair-step, froth and run white. On zoo grounds lie ruins: a covered bridge and one of the South's oldest cotton mills, which Sherman burned. Confederates torched the bridge, a futile attempt to keep Sherman out of Columbia.

I-26 soon steals Highway 76's identity, but thankfully, 76 divorces it near a gleaming Toyota dealership. Now 76 strings together beautiful beads of

small towns. It curves into Ballentine, named for E.A. Ballentine, who ran a general store in this Lexington County settlement. Built in 1929, it's the town's last original building. Political candidates once waxed eloquent here as wise, old men played checkers by the wood stove. Angie Rhame opened High Noon here on Valentine's Day 2007. Upon first walking in, an elderly woman told Rhame, "This does my heart good. I was so afraid they'd tear this place down. I have so many memories here." A train rumbles by each day at high noon (thus the name). In the old days, as the train rolled through, an attendant snagged a mailbag from a hook and hurled a sack of incoming mail to the ground. High Noon was Farm House Antiques from 1995 until 2006. The proprietor was Carlos Gibbons, father of Leeza, South Carolina's gift to national television.

Ballentine leads into White Rock, which melts into Chapin. From 76, you're a stone's throw from Beaufort Street and its eclectic shops, among them a gallery and NASCAR collectibles shop.

Just inside Newberry County, a thicket veils a vanquished farm—a poignant reminder of a time when small farms sustained this country. Just beyond Prosperity's old train depot sits the town square. There, too, sits a

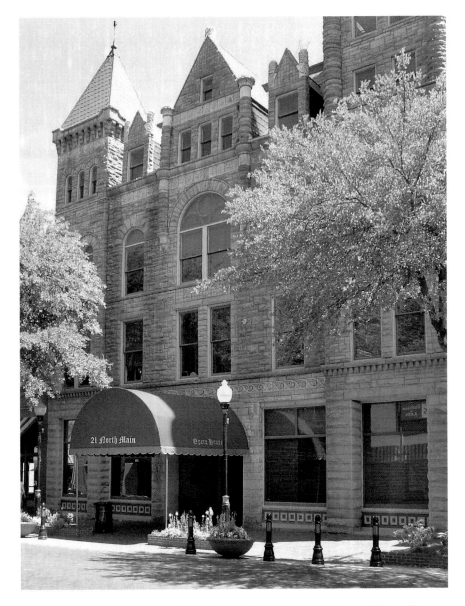

Above: Just off Highway 76, you'll find the Sumter Opera House, built from 1893 to 1895.

Opposite: The O'Donnell House was designed in the neoclassical style by Frank Pierce Milburn in 1905.

1935 granite block building. A Swede laid the granite blocks quarried in Winnsboro for $3.25 a day. This was where C. Boyd Bedenbaugh operated Bedenbaugh Mules and Horses. On Saturdays, farmers came to buy horses and mules. To gauge the temperament of the animals, farmers walked them around the public square before buying them.

Down the road apiece, an old '50s gas station, now a dusty antiques shop, speaks volumes about I-26's arrival. Toward Clinton, orange tiger paws adorn a shed's roof near a Christmas tree farm in 76's ongoing crazy quilt culture.

If you go:

Take a camera. (Some backtracking will be necessary unless you take other routes.)

ROAD TRIP DOWN HIGHWAY 76, LEG THREE

From Joanna to the Chattooga

In Joanna, on the eastern edge of Laurens County, the Blalock mausoleum dominates the Veterans' Memorial. Once known as Goldsville, Joanna now feels deserted. Beyond its outskirts, kudzu mobs deep woods. This topiary artist gone mad drowns local forests, and somewhere beyond its green masses, I know, farmers struggled to contain red gashes in the earth.

Through Laurens and on to Hickory Tavern. Land rises into green swells as I journey past the silver shoals of the Reedy River and on through Princeton, past aluminum frying pans hanging over some small-but-precious garden plant.

U.S. 178 cosigns with 76 from Honea Path to Anderson—the "Electric City," the South's first city to transmit long-distance electricity. On November 14, 1931, Amelia Earhart flew in to the original airport in her Pitcairn PCA-2 autogyro, promoting Beech-Nut products. Pondering her fate, I shoot beneath I-85 to La France past Pendleton's outskirts, where Samuel Augustus Maverick was born. Sam moved on to become an ornery Texas rancher, a "maverick" who signed the Texas Declaration of Independence. Thus, did "maverick" enrich our language.

Here in Foothills Country, the land climbs. To the left sits the entrance to the Botanical Gardens of South Carolina and its 295 acres of gardens and bogs. U.S. 76 crosses Lake Hartwell and the Seneca River, whose inundated riverbed joins the Tugaloo to create the mighty Savannah, that great river of sovereign delineation.

Looking like a town from the Old West, this shopping strip sits near Long Creek.

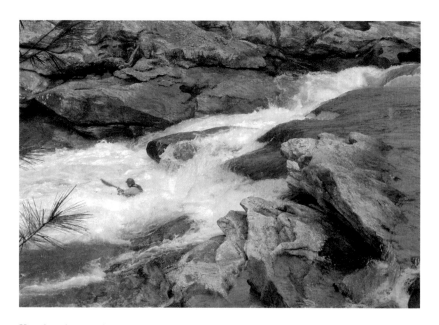

Kayakers love to shoot the gap at Bull Sluice.

Seneca, established in 1873, shipped cotton over its rails. Then the mills came. Today, Seneca possesses a homogenized look here and there—dollar stores, drugstores and Mexican restaurants. On to Westminster, just outside the dark green slopes of Sumter National Forest. All that greenery makes a doublewide trailer's bright purple roof appear radioactive. The theme of old and new commingled continues: a classic barn near Westminster faces a mobile home across Highway 76.

The Chauga River, a mini Chattooga, passes beneath you. Outside local trout fishermen, few know of the Chauga Narrows, a Class VI rapid. That's where the true earth exists—the earth too wild to tame.

The Wild West appears in Long Creek, a strip mall that looks like a place where a cowboy can hitch his horse and get a shot of whiskey. No cacti live here in faux frontier land, but apple orchards fill the green folds and creases.

Now the land plunges, turns and falls away—a roller coaster speed run. Tearing past Chattooga Whitewater Outfitters, a business owing its existence, in part, to *Deliverance* and the "land of nine-fingered people." Straight ahead looms the river of legend—the wild, unforgiving Chattooga. This river surely is like no other.

Highway 76, once a mere line on a map, now lives in your mind. You can place your finger on 76's thread-like presence and know that here hangs a deer head, here lies a sunken gunboat and here is great fried chicken. Opera houses, mobile homes, charred mansions and monstrous tractors. The blending of past and present has made your 76 explorations delightfully unpredictable. And best of all, you spent little time on an interstate.

If you go:

Take a camera. (Some backtracking is necessary unless you take other routes.)

TAKE A SENTIMENTAL JOURNEY

U.S. 1: The East Coast's Old Thoroughfare

Want to take a trip down memory lane? Want to just drive with no particular place to go? Drive U.S. 1 north through Elgin and continue on to the Tar Heel state line. Go as far as you like. Note, too, that you pass through the heart of Sand Hills State Forest. Tarry a while there before you visit Cheraw State Park, just up the road.

You'll pass through many a small town, hailed as places where values and virtues die with the greatest of reluctance. Mayberry comes to mind. It was a sleepy little town where good people and memorable characters lived.

I avoid interstates when I can, so I pass through a lot of small towns. And I can tell you that small-town America is dying, thanks in large part to interstate highways. See 'em while you can. One summer, I drove a road once mighty, U.S. 1—the main road from New York City to Miami once upon a time. It strung prosperous towns together like beads on a silver chain. Then I-95 tarnished the chain, and the beads lost their luster. Today, U.S. 1 runs past many an abandoned mom-and-pop store. All along its route, dust covers places that once thrived.

In the glory days, to have a business on U.S. 1's shoulder was to prosper. No more. It's easy to spot forsaken diners and gas stations from the 1950s and '60s. Dust can cover them, but it cannot destroy their classic architecture's lines. I urge you to drive this highway to see just how much our country has changed.

As for the old diners, stores and "filling stations"—what happened to the people who built and ran these places? Where did they go?

Driving along, I tried to summon up what it must have been like to see your livelihood destroyed by a monstrous freeway and the lure of saving time. Below Sanford, I drove by a service station/grocery store covered in vines, and suddenly it became easy. I imagined a thriving business with green-and-white hand-painted signs out front. "Fresh Vegetables." "Red, Ripe Tomatoes." "Cheap Gas." And then I-95 snaked its way across the land, and fewer eyes saw those simple advertisements. The hum of tires faded, and the clanging of cash registers quieted. More than one owner, I'm sure, made it a habit to stand in front of his store, hand shielding the sun from his eyes, scanning the road. "No traffic. Well, not like it used to be."

In leveling forests and plowing up fields and God knows what else to build 42,793 miles of limited-access pavement, the interstates changed America in ways few could have imagined. In 2004, *Forbes* magazine published "The Great Paving," which said, "The Interstate system was sold as a savior for both rural America and declining urban cores; instead it speeded the trend toward suburbanization at the expense of both city and country. It was heralded as an antidote to traffic jams; instead it brought ever more congestion."

You can still see vestiges of pre-interstate days. Hit U.S. Highway 1 and make a sentimental journey.

If you go:

Take a camera and fondness for nostalgia.

SANDHILLS STATE FOREST
16218 Highway 1
Patrick, SC 29584
843-498-6478

CHERAW STATE PARK
100 State Park Road
Cheraw, SC 29520
843-537-9656

THE CHATTOOGA

From springs and steams near Cashiers, North Carolina, grows a mighty river. Rising as a glittering mountain stream near Whitesides Mountain, the Chattooga flows ten miles in North Carolina before forming a forty-mile border between Georgia and South Carolina. The river drops 2,469 feet over fifty miles (49.3 feet per mile), creating a wild, dangerous run. The river surges, pools and slashes through "Chattooga Country," as *National Geographic* referred to it. It's also known as "Deliverance Country," owing to the 1972 film *Deliverance* that made it a legend.

Chattooga Country is up in Oconee County, approximately 160 miles away. Take I-26 to I-385 north to I-85 south and take SC-11 at Exit 1 toward Walhalla. It's slow going in the mountains, so allow yourself at least three hours to arrive at your chosen outfitter's headquarters. A night-before stay is advisable.

Let's make a very important point right up front. You do not want to run the Chattooga without the assistance of trained professionals. Note that this day trip provides three outfitters who can take you down the river. These outfitters provide safety equipment and trained guides familiar with the river's ways and dangers. The National Forestry Service regulates all three.

This savage-but-stunning river flows through ancient Cherokee lands, and to this day, it remains untamed. Dams straddle most rivers in the Southeast—not the Chattooga; it runs free. It attracts people from throughout the world. Fishermen, naturalists, novelists, environmentalists, essayists, filmmakers and the curious come to the Chattooga. Rafters and

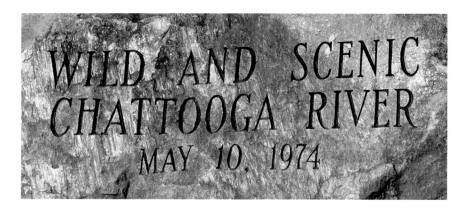

The Chattooga is one of the Southeast's longest, wildest rivers, surging over fifty miles.

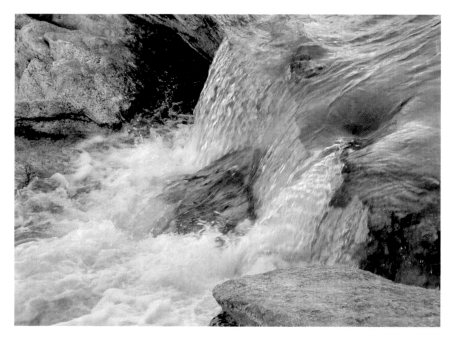

The Chattooga's power and fury pound rocks and river runners with no mercy.

veteran kayakers brave its Sections III and IV. The river has long attracted thrill seekers, many times fatally. The intimidated cling to its banks and stare.

Geological forces over millions of years carved out the Chattooga's path. When first formed, the Blue Ridge Mountains reached higher than the Rockies. Millennia of water and weather whittled away the jagged peaks and carved deep narrow valleys in the terrain. The Chattooga, designated a National and Scenic River, courses through this tumbled topography to become a river steeped in myth.

Hurdling downriver between canyon walls, rafters glide, pitch, jostle and buck on an untamable river. Guides who run the Chattooga must be unerring judges of depths, colors and shadows in order to avoid death traps perfected by geological processes 250 million years old.

Be advised: rafters on the Chattooga go from smiling to terror in the blink of an eye. Helmets and lifejackets are mandatory on this river that has claimed many a life. As quick as a pencil point breaks, rafters find themselves hurled into the river, where swift currents slam them against rocks. Approach this adventure with a serious attitude. Close to forty deaths have occurred here, one as recently as mid-July 2012.

If you go:

Choose from three outfitters, reservations required.

WILDWATER
Longcreek, SC
Reservations needed for rafting and ziplining "canopy tours"
Rafting fee includes riverside lunch
866-319-8870
www.wildwaterrafting.com

SOUTHEASTERN EXPEDITIONS
Clayton, GA
706-782-4331
www.southeasternexpeditions.com

NANTAHALA OUTDOOR CENTER
Clayton, GA
888-905-7238
www.noc.com

THE WALHALLA STATE FISH HATCHERY

About 168 miles and a little over three hours will take you to a memorable place: the Walhalla State Fish Hatchery. Make your way to Walhalla and follow the directions at the end of this column. If you come away with a desire to go fishing and a hankering for fried trout, blame it on this column.

Summer is a good time to make the trip. Green, leafy mountains and winding roads make for a calming effect, something quite the opposite of the fish-frenzied Walhalla State Fish Hatchery. Walking through the hatchery, you'll see fingerlings aplenty, all swimming to and fro, churning the waters.

The old hatchery is easy on the eyes. The Works Progress Administration and the Civilian Conservation Corps built it in the 1930s. Make note of the beautiful rock architecture. Earth tones and hues do much to make the hatchery blend into the mountain environment. It's said the rocks came from nearby mountains.

The hatchery is the only cold-water fish hatchery the South Carolina Department of Natural Resources operates. Brown, brook and rainbow trout are raised here for stocking the public waters of South Carolina. Most trout are cultured to a size of nine to twelve inches before being released. About half a million trout are produced and stocked annually. You can see large trout ranging from five to fifteen pounds at the hatchery as well.

Visitors are welcome to tour the hatchery and to fish in the East Fork, which runs through hatchery grounds. You'll find places to picnic, too.

Belong to a fishing club? You can plan special group tours by calling the hatchery. (The best time of year to schedule group tours is in the fall.) Visits

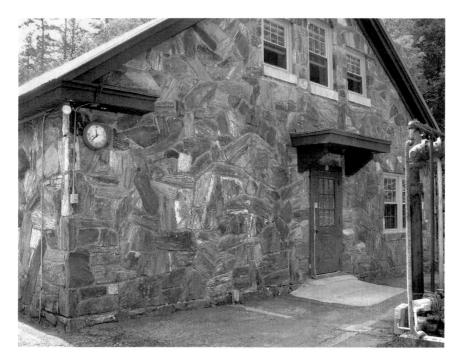

The skill of the CCC stonemasons gave the hatchery a strong but quaint appearance.

by individuals and families take place on a walk-through basis. The day I was there, several families were touring the hatchery. Kids love to see the fish up close, and they get a thrill when the fish splash them.

You'll find plenty to do when you're done visiting the hatchery. Adjacent to the hatchery is the Chattooga Picnic Area, operated by the U.S. Forest Service. Next to the picnic area is the boundary of the Ellicott Rock Wilderness. Hikers may take a trail that goes along side the East Fork for 2.5 miles to the Chattooga River. From there, you can go upstream to Ellicott's Rock (1.7 miles) or downstream to the Burrell's Ford campground and parking lot (2.1 miles). Request a trail map.

On Highway 107 south toward Walhalla is the Oconee State Park. Here there are cabins, camping areas, swimming and numerous other recreational activities. It's refreshing to go to the mountains when summer heats up the land, and you'll find it educational to learn about the life cycle of trout. And then you can plan a fishing trip and have that fish fry I mentioned earlier.

If you go:

WALHALLA STATE FISH HATCHERY
198 Fish Hatchery Road
Mountain Rest, SC 29664
864-638-2866
http://hatcheries.dnr.sc.gov/walhalla/tour.html

OPEN FROM 8:00 A.M. TO 4:00 P.M.
There may be a few exceptions during the winter months if inclement weather makes conditions unsafe for visitation. The hatchery is closed on Christmas Day.

WATERFALL COUNTRY

You'll find more than fifty waterfalls in the Palmetto State. They plummet anywhere from forty to seven hundred feet, and one, Whitewater, even has the North Carolina–South Carolina border running between its upper and lower falls. Some you can easily reach; others are hidden and can be reached only after a good hike. The terrain can be rugged and the going tough. It helps to be in good shape.

The falls have names that convey the thundering, crashing symphony of water awaiting you. Issaquena Falls you'll find in Stumphouse Tunnel Park above Walhalla. Dropping two hundred feet, it's one of the more popular waterfalls. Not far away is Whitewater Falls. You'll find it off secondary road S-39-171. Whitewater actually consists of two sets of falls, and it's eastern America's highest series of falls, plunging approximately seven hundred feet before its water finds its way into Lake Jocassee.

Another falls within striking distance is Raven Cliffs Falls in the Mountain Bridge Wilderness and Recreation Area. Many consider its 420-foot drop to be majestic. Be forewarned that a two-mile hike is necessary to see this stunning cataract.

If you can handle a fairly short hike, Oconee Station Falls, known also as Station Cove Falls, won't disappoint you. It flows over the edge of a fifty-foot-high ledge at the end of a 0.7-mile trail in Oconee Station State Park near Walhalla. This park, by the way, features several Revolutionary War–era structures worth seeing. To see this waterfall, drive from Walhalla, taking SC 183 north for 3.0 miles to SC 11, the Cherokee Foothills Scenic Highway.

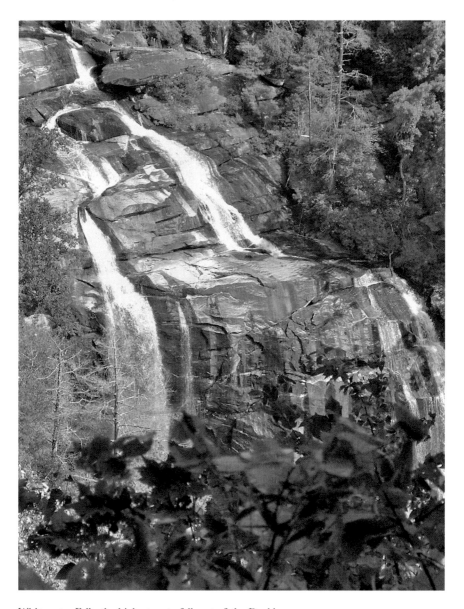

Whitewater Falls, the highest waterfall east of the Rockies.

Follow SC 11 north for 2.0 miles. You'll see signs directing you to Oconee Station State Park.

The South Carolina Upcountry glitters with waterfalls. Falls Creek Falls drops its beauty one hundred feet in two levels. Rainbow Falls plummets eighty to one hundred feet over colorful granite. Twin Falls splits Reedy Cove Creek; one fall drops over a granite wall and the other over boulders.

Plan to stay in one of the fine state parks up in the Northwest Corner because you'll find many falls in state parks. Base camps for hiking and exploring waterfalls abound. There's Caesars Head State Park, Jones Gap State Park, Devils Fork, Keowee-Toxaway, Table Rock and its most-photographed mountain in South Carolina.

Maybe you should do some walking or even jog some to get conditioned for hiking the mountains. The reward will be worth it. There's something special about the most powerful weathering element on the planet wearing away at granite and gneiss. It's an awe-inspiring collision. Imagine you're there now. Ahead there is a roar, understated but growing. After a few more turns, the air thunders and shakes, and mists chill the wind. Then you see it: a majestic drapery of water pounding a bed of granite. You behold the classic unmovable object and the irresistible force.

If you go:

About 154 miles (two hours and thirty-nine minutes) will take you to Walhalla. Wear non-slip shoes and be sure to visit the South Carolina Department of Parks, Recreation and Tourism's "Mountain's and Waterfalls" website: www.southcarolinaparks.com/things-to-do/mountains-waterfalls.

GAS UP AND HIT THE ROAD

Day Trips 101 to 150 Miles Away

THE ANGEL OAK: A TREE FOR THE AGES

Monarch of the Lowcountry

Down on John's Island, you can see a southern live oak estimated to be between 500 and 1,500 years old, one of the oldest living things east of the Mississippi River. Most experts estimate the Angel Oak to be 1,500 years old, but precisely determining this monarch's age is difficult because heart rot prevents coring. (Counting growth rings just isn't possible.)

Want to see this Millennium Tree, this 2004 South Carolina Heritage Tree? Then make the 123-mile day trip to John's Island, which takes about two hours. It's been said that this giant tree and its outspread limbs appear angelic, hence the name. But that isn't how it got its name. No, the name comes from its long-ago owners, Martha and Justus Angel. Then as now, local legends maintain that ghosts of former slaves appeared as angels around the tree.

That the Angel Oak exists is a miracle. A visitor from New England, emotionally moved upon seeing the ancient tree, wrote, "It is hard to believe that over the years, man has not found a reason to get rid of this old tree. The fact that is it is still around and lovingly tended gives me hope." Well put.

When you walk the grounds around the Angel Oak, you walk in the footsteps of early settlers and ancestors of the Gullah. Over the years, the sixty-five-foot-high tree has grown out more than up. And over the years, its seventeen thousand square feet of shade surely has shielded a legion of Lowcountry denizens from the blazing southern sun. (You cannot approach

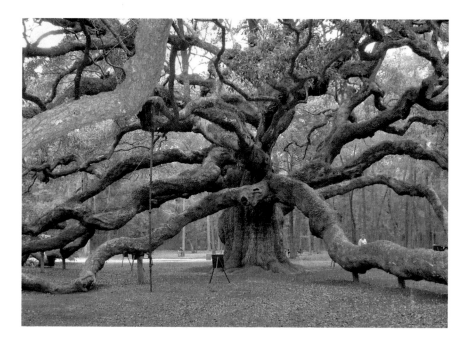

The Angel Oak shades seventeen thousand square feet and has survived floods, earthquakes and hurricanes.

too closely or climb the tree's graceful arching limbs, many as big as full-grown oaks themselves. The largest limb has a circumference of over eleven feet.)

The Angel Oak is one of those iconic images that proclaim, "You're in the classic Lowcountry." To see the majestic oak is to conjure up Lowcountry swamps, blackwater rivers and Spanish moss. The Angel Oak and the Lowcountry go together like William Faulkner and Mississippi, like Sidney Lanier and the "Marshes of Glynn" and like shrimp and grits. You won't find an antebellum movie about South Carolina that doesn't show live oaks draped with Spanish moss. In fact, moss-draped oaks and cypress forever frame the Lowcountry's image, and the Angel Oak, the star of stars, holds court over them all.

Revered and held sacred, the Angel Oak is a tree for the ages. It'll hold you in a spell. Finally, when your sojourn at Angel Oak is over, Charleston is just thirteen miles away. There's much to see and do down here. Just one favor before you go. The City of Charleston owns and maintains the Angel Oak and its park. Buy something at the Angel Oak gift shop or leave a donation to help protect this tree so vital to all.

If you go:

ANGEL OAK PARK
3688 Angel Oak Road
John's Island, SC 29945
843-559-3496

Free Admission

BEAUFORT NATIONAL CEMETERY

A Beautiful Place of Rest

How well I remember the opening scenes of *Saving Private Ryan*. No one can watch Harrison Young's portrayal of the present-day James Francis Ryan and maintain any semblance of composure. Walking amid the marble crosses, he's overcome with emotion as he sees the cross of the man who saved him. It's one of the most touching cinematic moments I recall.

I've always wanted to see the cemetery at 14710 Colleville-sur-Mer, France, but it is a bit out of the way. I'd love to go to Arlington National Cemetery, but it's 487 miles distant, some seven and a half hours away. We have options, however.

South Carolina has three national cemeteries: one in Florence, one at Fort Jackson and one in Beaufort. If you want to see saintly splendor, I suggest you make a day trip to Beaufort National Cemetery. If you've not seen the precise rows of gleaming marble monuments standing beneath moss-draped live oaks, it's time you did. Its graves radiate out from the flag circle like a fan with roads arranged like the spokes of a wheel.

I was there in October. The combination of pure sunlight, green grass yet to fade and rows of marble headstones standing as precisely as if a laser laid them out is overpowering. The exactness with which the headstones stand cannot be appreciated except in person. And the marble monuments stand solid to the touch, lasting memorials to the veterans lying beneath them. Something about Spanish moss, the Gray Lady of the Lowcountry and the way sunlight strikes it and the marble stones enhance the beauty of this place of eternal rest.

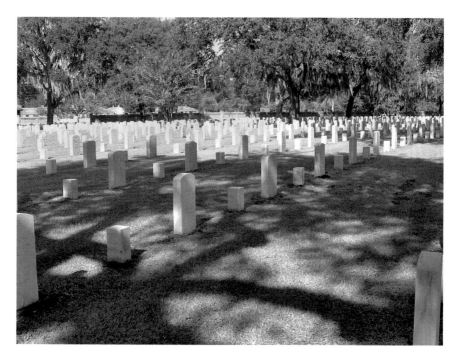

Beaufort National Cemetery—33.1 acres of service, sacrifice and memories.

The Great Santini lies here along with veterans of both sides of the Civil War. A German prisoner of war rests here as well. Veterans from World War I and World War II lie at rest here, of course, as well as veterans from the Spanish-American War, the Korean War, the Vietnam War and the Gulf War. It's a contemplative experience to walk among so many veterans, many of whom made the ultimate sacrifice.

Once you leave the cemetery, downtown Beaufort is very close by. In 2013, *Coastal Living* magazine ranked Beaufort number one when it came to "America's Happiest Seaside Towns." Lift your spirits a bit and walk its beautiful streets and dine at one of its fine restaurants. Head to the waterfront and see the sailboats moored securely within view of massive live oaks. See, too, the famous homes made even more famous in movies like *The Big Chill* and *The Prince of Tides*. There's much to see and do here, but do pay the Beaufort National Cemetery a respectful visit. The cemetery was placed on the National Register of Historic Places in 1997. You can place it on your calendar as one of the places to visit when you go to Beaufort.

If you go:

2.5 Hours, 136 miles
1601 Boundary Street
Beaufort, SC
843-524-3925
Open daily from 8:00 a.m. to sunset
www.cem.va.gov/cems/nchp/beaufort.asp

CAESARS HEAD

Where Hawks Ride Thermals

About 134 miles away in northern Greenville County, you'll find one of the Blue Ridge Escarpment's more prominent landmarks, Caesars Head. Some believe this rock outcropping resembles the Roman emperor Caesar, thus its name, though some believe the landmark took its name from an early pioneer's dog. Regardless of its origin, Caesars Head surveys a kingdom of stunning views, and the landmark's name gives Caesars Head State Park its identify as well.

Caesars Head, composed of durable granitic gneiss more than 400 million years old, connects to Jones Gap State Park in the Mountain Bridge Wilderness Area, an eleven-thousand-acre area of pristine southern mountain forest. Driving through the Mountain Bridge Wilderness Area, you'll encounter curves aplenty and scenic overlooks. Highway 276, a road favored by mountain lovers, delights travelers between Brevard, North Carolina, and Pumpkintown. Its hairpin turns and steep grades challenge drivers who motor up 3,208 feet to Caesars Head State Park. Come autumn, colors pull hard at leaf worshipers, and Highway 276 sees its share of fall foliage and sightseers.

Atop Caesars Head, you stand upon the Blue Ridge Escarpment—3,266 feet above sea level. From here, you can see Georgia and North Carolina. The panoramic view includes Paris Mountain near Greenville. In the fall, people come to watch hawks wheeling and spiraling—a process called "kettling"—as they migrate to Central and South America for the winter.

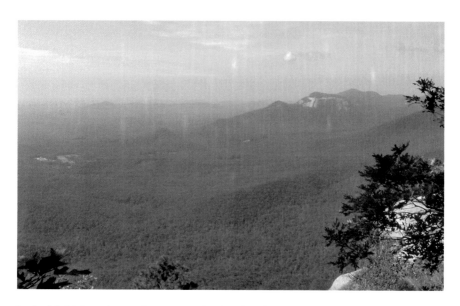

In the fall, bird-watchers gather to count hawks migrating to Central and South America.

You, too, can migrate from here. Day hike to one of eastern United State's highest and beautiful falls, Raven Cliff Falls near Caesar's Head, which plummets some 420 feet. Brave? Cross its swinging footbridge Indiana Jones style. Shaky-step your way across and brag about it later.

A drive up to Caesars Head and its namesake park never disappoints. There's much to do (bird watching, especially autumn's hawks; camping; and fishing) and many waterfalls to see. Keep an eye out for black bear. Make the trip in autumn, and you can see fall color aplenty. Make the drive in summer, and enjoy the cooler air. It's a good place to be active. Over fifty miles of hiking trails will test your legs. Primitive camping is available here, too. Pack a picnic basket and enjoy eating at one of the picnic tables and shelters. Be sure to make the tight descent through cracked rock walls known as the "Devil's Kitchen."

Put the visitor's center on your schedule. It houses exhibits of area attractions, a relief map of the Mountain Bridge trail system, hawk displays and gift and souvenir items. It's open daily from 9:00 a.m. to 5:00 p.m. during daylight saving time. It's closed on Thanksgiving and Christmas Day.

If you go:

Driving up through Greenville, it takes two hours and twenty minutes to get to Caesars Head. Take Highway 276 west for about thirty miles. The park is located at the top of the mountain right off the highway. Admission is free. The North Carolina border is three miles away.

CAESARS HEAD STATE PARK
8155 Greer Highway
Cleveland, SC 29635
864-836-6115
www.southcarolinaparks.com/caesarshead/introduction.aspx

CAMPBELL'S COVERED BRIDGE

Carolina Americana

I never saw an authentic covered bridge until Clint Eastwood directed and starred with Meryl Streep in *The Bridges of Madison County*. Genuine covered bridges in these parts are as rare as hens' teeth. Several years ago, though, I came across the real deal: a covered bridge up in northern Greenville. It was late afternoon, when sunlight comes in so low that everything is golden and lustrous but driving is hard. A bit blinded as I rounded a curve, I got a treat as my eyes adjusted—it was Campbell's Covered Bridge.

You can see it, too. Just head to Landrum. Drive 118 miles, and you'll find the covered bridge near the small town of Gowensville, not quite two hours away. South Carolina's last remaining covered bridge crosses Beaverdam Creek. Greenville County owns the bridge and closed it to traffic in the early 1980s. It was added to the National Register of Historic Places on July 1, 2009. Major renovations have kept the bridge in good shape.

In 1909, Charles Irwin Willis built the thirty-eight-foot-long, twelve-foot-wide pine structure. The bridge was named for Lafayette Campbell, who, at the time of the bridge's construction, owned 194 acres in the immediate area. Campbell owned a nearby gristmill, and he let his property be used for the bridge's construction. Willis was no dummy. He knew area farmers could better bring their corn to his mill across the creek.

The Greenville County Recreation District has transformed the surrounding acreage into a park where visitors can picnic, explore the foundations of the old gristmill and home site, wet their feet in Beaverdam Creek and learn about the area through interpretive signage.

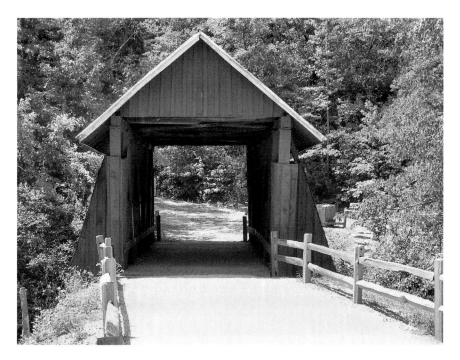

The "Bridge of Greenville County" is thirty-eight feet long and twelve feet wide.

I loved the old bridge. I got out and walked inside the bridge, struck by its narrow width, which is just right for horse-drawn buggies. Through cracks in the wooden flooring, I saw and heard Beaverdam Creek running cold and swift over rocks. Everything was peaceful, the air a bit chilled. I stayed there a while trying to envision the many years long ago when old cars and carts rolled through and no one gave a second thought to the bridge's uniqueness. I'm sure it made for a nice spot for couples once the busy day settled down—a *Bridges of Madison County* spot, so to speak, for lovers. I walked out from the bridge as darkness settled in, and just then a young couple drove up. They looked at me, a stranger, as if I didn't belong there. And I didn't.

I was glad to see the old bridge still had allure, still had its pull on romantic souls. It will pull on yours, too. It's there. The bridge and the surrounding area are quiet, peaceful and beautiful. Pack a picnic come fall, when the leaves burst with color, and visit this rare bit of Americana. Be sure you take photos of this rare covered bridge. Once you're ready to move on, you're not far from SC Highway 11, the Cherokee Foothills Scenic Highway. Look

for mountain vistas, handmade quilts, apples, apple jelly and honey for sale. Return home with great moments to remember.

If you go:

CAMPBELL'S COVERED BRIDGE
171 Campbell's Covered Bridge Road
Landrum, SC 29356

CAPE ROMAIN WILDLIFE REFUGE

See Boneyard Beach, Birds and Unparalleled Beauty

Ready for a challenging day trip? A journey 130 miles one way by land before heading out to sea? Visit Cape Romain Wildlife Refuge offshore from Awendaw, South Carolina. Trailer your boat or make plans to ferry over to Bulls Island for a truly wild and awe-inspiring adventure.

At five thousand acres, Bulls Island is the largest barrier island in the refuge. Take a good camera. You'll want to photograph Boneyard Beach, where toppled trees litter the beach for a three-mile stretch at the island's northeast end. The Atlantic's tides undercut the trees' roots, and down they go. Trees with sun-bleached limbs white as marble lie about. The sea-ravaged maritime forest leaves you breathless.

Another strong draw is wildlife. Beautiful creatures ennoble the refuge. Orange-billed oystercatchers and white egrets stand out against green spartina. Bird watching is good year-round. Birds are busy come summer, raising their young on the beaches and in the maritime forest. Deer, alligators, raccoons and black fox squirrels live here, but the island's bird life is famous worldwide. Over 293 species of birds have been recorded on the refuge, with most being found on or near Bulls Island. The cup of life overflows here.

History has laid its hand on the island. Sewee Indians lived here before settlers arrived. It's said that pirates hid out in Bulls Bay and the creeks behind Bulls Island. From these hideouts, they attacked ships along the coast. The remains of an "old fort" are believed to have been a lookout tower built in the early 1700s. During the Revolutionary War, British warships used

the island to replenish supplies. Confederate blockade-runners hid in creeks here. The island's history is rich, for sure.

At Bulls Island, you can surf fish, watch wildlife, picnic, hike and bike. And when you get back to the mainland, visit the Sewee Visitor and Environmental Center at 5821 Highway 17 North in Awendaw. Jointly operated by the U.S. Fish and Wildlife Service and the U.S. Forest Service, the Sewee Center will teach you about the ecosystems of Cape Romain National Wildlife Refuge and the Francis Marion National Forest. And be sure to see the center's endangered red wolves.

If you go:

Take I-26 to Exit 212 and go east on I-526 for 12.0 miles. Exit onto U.S. 17 north and then go northeast for 10.8 miles. Turn right onto Sewee Road, go northeast for 3.4 miles and then turn right onto Bull Island Road. Follow this road to Garris Landing. Depart by boat from Garris Landing. Bulls Island lies 3.0 miles off the mainland. The island has a public dock where you can take personal watercraft during daylight hours. Restrooms, a covered shelter and picnic area also exist.

Coastal Expeditions, the refuge concessionaire, operates a ferry that provides regularly scheduled trips from March 1 through November 30 on Tuesday, Thursday, Friday and Saturday. It's forty dollars for adults and twenty dollars for children twelve and under. Reservations are not required but are recommended. Call Coastal Expeditions at 843-881-4582 or visit www.coastalexpeditions.com.

Learn more about the refuge at www.fws.gov/caperomain/ bullsisland.html.

The Sewee Center operates Tuesday through Saturday from 9:00 a.m. to 5:00 p.m.
843-928-3368

CHARLESTON TEA PLANTATION

Tea Time

Southerners swear by their iced tea. In the South, iced tea is not just a summertime drink; it's served year-round with most meals. And here in South Carolina, the connection with tea is especially strong. It's the first place in the United States where tea was grown and the only state that produces tea commercially, a process that you can see in person. Just twenty miles west of Charleston on Wadmalaw Island, you can visit the country's only tea plantation. There you'll find the Charleston Tea Plantation, a 127-acre working farm and the home of American Classic Tea.

About 130 miles away, Wadmalaw Island (just saying that name is a pleasure) provides the perfect environment for propagating tea. With its sandy soils, subtropical climate and average rainfall of fifty-two inches per year, Wadmalaw provides idyllic conditions for *Camellia sinensis*. This plant produces both black and green teas, and over 320 varieties grow on the plantation, which bills itself as "America's Only Tea Garden."

Take the Factory Tour, during which flat-screen televisions guide you down a glass viewing area overlooking the factory. Inhale the heady aroma of fresh tea being processed. Learn about the production of our American Classic Tea, the Charleston Tea Plantation's story and tea's colorful history. (In colonial days, the British went to China to buy tea plants, but the Chinese sold them camellias instead—an easy ruse since camellias and tea plants are botanical cousins. That's how we got camellias!)

You'll see that it takes a lot of work to fill a glass with iced tea. In fact, it takes five pounds of leaves to produce a pound of tea. Fresh green leaves

roast overnight in the withering bed, where moisture drops from 80 to 68 percent. Key processes include oxidation and drying at a temperature as high as 250 degrees Fahrenheit.

Take the thirty-five- to forty-minute Trolley Tour and enjoy a scenic ride around the 127-acre farm. William Barclay Hall, founder of American Classic Tea and world-renowned tea taster, narrates the tour. He'll educate you about the history of America's tea garden while challenging your knowledge of tea. (A tea bush can live six hundred years!)

Walk the grounds. Stop by the Propagation Hut and read how the plantation selects the best quality plants for new acreage through cloning. Browse the shop, where a variety of products feature tea ingredients and connections.

Bring the family, pack a lunch and see the beautiful tea fields. The Charleston Tea Plantation offers a unique Lowcountry experience—one you'll appreciate all summer as you sip sweet iced tea.

If you go:

6617 Maybank Highway
Wadmalaw Island, SC 29487-7006
843-577-3311
www.charlestonteaplantation.com

There is no general admission fee. Trolley Tours are ten dollars for twelve years and up and five dollars for those under twelve. The plantation is open 10:00 a.m. to 4:00 p.m. Monday through Saturday and 12:00 p.m. to 4:00 p.m. on Sundays. It's closed on major holidays.

COLLINS OLE TOWNE

A Rural Community of the 1930s Lives On

Make the two-hour, six-minute/127-mile drive to Central, South Carolina, and you'll find a country community of the 1930s, the brainchild of Roy and Pat Collins. While many remember the 1930s as the era of the Great Depression, it was also a time when life was pragmatic and picturesque, a rare combination these days. At Collins Ole Towne, you can step back in time and see a vintage barn, an old school, a barbershop, a mill and a general store.

The Collinses built their community onsite. Much of the material used came from old homes marked for demolition or renovation. What's truly fascinating is the old general store. Back in olden times, folks needed liniment, castor oil and seeds. You'll find those as well as memorabilia from life in a small community. Country store paraphernalia from the 1820s into the mid-1950s gives visitors an Americana feeling, and yes, the store has a vintage Coca-Cola box.

Check out the Issaqueena Mill, a three-legged mill with a wooden hopper, once used on large farms and small plantations. Today, old plows, telephone conductors, old bottles and relics rest in it. When you're there, note the old upside-down horseshoe above the center post leaking away its good luck.

The Depression-era barbershop features a reconstructed motorized barber pole, a coat rack and several other items used in an old barbershop in Central. The Collinses purchased the barber chair, pedestal lavatory and many other items of interest during their travels.

CLASSIC CAROLINA ROAD TRIPS FROM COLUMBIA

The latest addition to Ole Towne is the schoolhouse, which has a bell tower. Pull on the rope, and it's school time again. Sit in an old desk dating back to the early part of the century. See old school books and other memorabilia. Note, too, the wood-burning heater that kept winter's frigid days at bay.

Once Collins Ole Towne gets you in a "good old days mood," make the thirteen-mile drive up to Pickens and visit Hagood Mill. Before refrigerators came along, cornmeal had a shelf life of about two weeks. This gristmill near Pickens churned out fresh meal from 1845 until the mid-1960s. You'll find the mill on Hagood Creek. The water wheel, twenty feet in diameter by four feet wide, is South Carolina's only wooden waterwheel. The wheel and mechanical components were rebuilt in the mid-1970s using as many original parts as possible. Restoration continued in the mid-1980s up into the mid-1990s. It's on the National Register of Historic Places.

Pay attention to the millstones. A revolving upper millstone, the "runner," and a stationary bottom stone, the "bed," gave old mills their heart. The stones weigh more than a ton, and as they rub against each other, grooves cut into them create a scissor-like action that grinds grain. To this day, a lot of folks believe stone-ground grain tastes better than grain ground by modern roller milling methods.

A quaint village much like a Hollywood set, a picturesque gristmill and a drive through beautiful countryside: if those aren't reasons enough to head to the cooler climes of the mountains, then what is?

If you go:

COLLINS OLE TOWNE
228 Lawton Road
Central, SC
864-639-2618
www.centralheritage.org/town.htm
Call for an appointment to tour the village.

COWPENS

Where the War Turned

'Tis a small place, this town called Cowpens, but it looms large in our country's fight for independence. Just nine miles out of Spartanburg, Cowpens and its rich history are about 114 miles away. The unusual name comes from the fact that this area was an overnight stop for men driving cattle through the area. It's also the place that one British military leader wished he had never visited.

A daytrip to Cowpens will take you to a pasture-like setting key to the winning of the Revolutionary War. If a bit of a history buff lives in you, you'll be right at home at the Cowpens National Battlefield near Chesnee. It was here that a classic-but-rare double envelopment military maneuver took place, one studied to this day by military strategists and historians. Officers still draw up the battle on paper and pour over the decisions and movements of both armies and their leaders. They seek to understand why the "double envelopment" maneuver worked, as well as how to defend against it.

The battle took place on January 17, 1781, when Brigadier General Daniel Morgan of the Continental army took on Lieutenant Colonel Banastre Tarleton's British forces. Morgan's decisive victory at Cowpens became a turning point in the Revolutionary War. General Morgan had fought in the French and Indian War twenty years earlier and was a seasoned and creative leader. He had a grasp of war and knew how his men would react in battle. And he had a pretty good idea what Tarleton would do. At twenty-six, "Bloody Ban" Tarleton was to be feared. He gave little quarter and was known for fighting until his last man fell.

Though known for his boldness on the battlefield, Tarleton turned tail and fled when Morgan outflanked, surrounded and then turned the tables on him. The redcoats weren't coming. They were running for their lives! Morgan's double envelopment strategy of dividing his troops and attacking the British army's flanks delivered victory in less than an hour. This battle, an important link in a chain of events, led to the defeat of the British and independence for the colonies.

Head up to Cowpens National Battlefield and envision the scene where Morgan and Tarleton faced off. You can drive the 3.8-mile auto loop around the battlefield's perimeter and get a feeling as to how the British were surrounded.

Featured at the battlefield is a walking trail and marked road tour, a picnic ground and a visitors' center with exhibits, memorabilia and a multi-image presentation. You'll see a reproduction of a three-pounder cannon, other weapons of the Revolutionary War period and exhibits.

At 845 acres, it's a big place. Plan a good day here. Walk the interpretive trail. Take a picnic lunch or a cooler loaded with steaks, hot dogs, etc. The park has picnic tables, grills and restrooms. Be sure to visit the Robert Scruggs House (circa 1828) while at the park. History was made here, and it's waiting for you.

If you go:

4001 Chesnee Highway
Gaffney, SC 29341
863-461-2828
www.nps.gov/cowp/index.htm
Open 9:00 a.m. to 5:00 p.m. all year (except Thanksgiving)

FOLLY BEACH

Some say Folly Beach is South Carolina's best beach, and a growing number of people agree. Just eight miles south of the Holy City, the "Edge of America," as Folly Beach bills itself, is indeed a special place. This seven-mile-long barrier reef offers much to people of varied interests: super waves for surfing, an old lighthouse, a great restaurant for the health conscious and a place popular with pet lovers. I know because a highly reliable but secret source emailed me. "One place I've newly discovered and just love because it is extremely dog friendly is Folly Beach. It totally embraces dogs (in the hotel, on the beach, etc.). There are dogs everywhere, and they are wonderfully behaved."

There's even a Lost Dog Café in this place referred to as one of the last real American beach towns. That and more. My source continued, "There's this little beach shop area close to the hotel that reminds me of Five Points in Columbia. Plus I am a vegetarian, and there is a wonderful vegetarian place there, Black Magic, with about 50 kinds of fresh fruit smoothie combinations. They mix the fruit as you wait."

My journalist from the field points out that you'll find "many good eateries in the little five points place." Those who prefer more formal eateries will find those, too, plus Charleston is close. My source loves Folly because it "has everything a big beach resort has"—so don't be surprised if you don't make it to Charleston.

Now about that name—"Folly." We all know about Seward's Folly, that foolish purchase that gave us Alaska and its wonderful resources. Like

Alaska, neither is Folly Beach bedeviled by a "foolish" perception. When early settlers in their creaking ships first saw the pristine, tree-lined coast here, it was their first sight of trees in a long, long time. Rejoicing, they christened their newfound Eden "Folly." Why? Because "folly" is an Old English word meaning "cluster of trees" or "thicket." So there.

No, there's nothing foolish about Folly Beach. In fact, it's just the opposite. It's is the new cool place to go. You can relax and take in nature. You can spend a dog day afternoon on the beach, surf, catch a glimpse of loggerhead turtles, bicycle, kayak or drop a line from the fishing pier. Just be sure you go earlier than later. It's good to beat the crowd when you're headed to the Edge of America.

If you go:

124 miles (two hours and three minutes)
www.cityoffollybeach.com

FORT FREMONT AND THE CHAPEL OF EASE

You'll come across the ruins of an old fort and old chapel on St. Helena Island. Both picturesque. Both historic. This excursion into ruins and history might require an overnight stay, but if you do you will be glad you did. Beaufort has fine restaurants and hotels and is itself a worthy destination. This day trip could easily turn into a two-day trip when you consider all this region harbors.

The drive from Beaufort down Highway 21 itself is picturesque, with splendid views of the marsh. Avenues of live oaks give the drive a classic Lowcountry atmosphere. You'll find Fort Fremont Park at the southwestern tip of St. Helena Island. When you arrive at the old fort, a Port Royal panorama awaits in back of the fort. See the wide expanse of water into which European explorers sailed.

The Fort Fremont Park site fronts nine hundred feet of Port Royal, a historic sight itself. Frenchman Jean Ribault sailed in here in 1562 and founded the short-lived settlement of Charlesfort on Parris Island. Port Royal was the site of the Battle of Port Royal during the Civil War.

Beaufort County owns the old fort and its grounds. It's typically quiet with few visitors. Built because of the 1898 Spanish-American War in 1899, the fort's purpose was to defend the region from the Spanish. The fort's "Endicott Batteries" accommodated disappearing guns of eight-, ten-, twelve- and sixteen-inch diameters and ten- and twelve-inch mortars. Fort Fremont also bristled with ten-inch disappearing guns and a rapid-fire battery. Climbing over the old fort, you can see the turrets and bolts where guns sat.

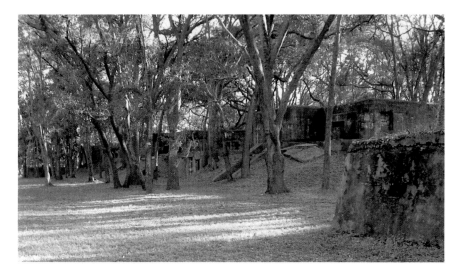

Fort Fremont's land-facing side. The fort was originally built as protection from the Spanish and featured three disappearing ten-inch guns. It was deactivated in 1921.

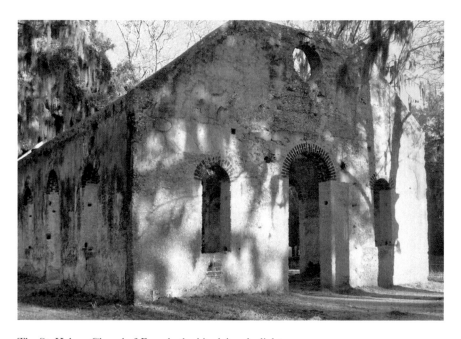

The St. Helena Chapel of Ease, bathed in dying daylight.

At its peak, the fort covered seventy acres and included a hospital, barracks, stables, guardhouses, a commissary and other support buildings. Only two batteries and the hospital building remain.

The fort takes its name from General Charles C. Fremont, a Savannah native. General Fremont had played an enormous role in capturing California from Mexico years before. Fort Fremont was deactivated as a military installation in 1921. Now if you listen to legends, only ghosts dwell here. The "Lands End Light" is well known by locals. One tale recounts that the light is the lantern of a Confederate soldier patrolling Land's End Road in 1861. A Yankee soldier or soldiers caught him off guard and cut off his head. All these years later, he walks the road with his old iron lantern seeking his head.

On your way back, be sure to stop and visit the St. Helena Chapel of Ease. Destroyed by an 1886 forest fire, the chapel, built in the mid-1700s, is a shell today. Tabby walls and old brick are all that remain. With Beaufort's main parish church a bit too far, this chapel of ease made it more convenient for planters and their families to worship.

If you go:

About 148 miles; not quite three hours. To get to Fort Fremont from Beaufort, follow U.S. 21 east to Frogmore. Turn right at Martin Luther King Boulevard and drive 7.7 miles. The entrance to Fort Fremont Preserve will be on the right. To get to the St. Helena Chapel of Ease ruins, take SC Secondary Road 45 in St. Helena.

www.fortfremont.org/index.html (Fort Fremont)
www.nationalregister.sc.gov/beaufort/S10817707045 (Chapel of Ease)

GEORGETOWN: WHERE RICE WAS GOLDEN

The Lowcountry's Unsung Jewel

About 127 miles away, you'll discover a Lowcountry jewel that too often takes a back seat to Beaufort and Charleston. The seaport of Georgetown (2.5-hour drive) delights visitors and residents with its elegant homes, harbor walk, ancient oaks, majestic rice plantations and history. Some historians, in fact, point to Georgetown as the earliest settlement in North America. How ironic that South Carolina's third-oldest town might be North America's oldest—and it's just a day away.

If you've never visited an old rice plantation, you should. In and around Georgetown, glimpses of the Old South are yours for the taking. Beautiful plantations abound here, among them Estherville, Millbrook and Mansfield. Of course, you can't just go to these plantations; they are private homes. But one, Mansfield, operates a bed-and-breakfast, and if you want to extend your day trip, that's the place to do it. *Garden & Gun* magazine says Mansfield is like "traveling to another era." It takes you back to the 1700s.

You'll see the allée of oaks Mel Gibson rode through in *The Patriot*, but more importantly, you'll discover vestiges of an old rice plantation. The country's last winnowing tower—a building on high stilt-like supports where women separated chaff from rice—still stands. Women would sweep rice over the floor cracks, and as rice fell into a muslin tarp below, the chaff blew away. You'll see slave cabins and a slave chapel, too. Poignant beauty lives in the chapel's simple lines, old wood and ancient bricks.

Another beautiful old home can be found at Millbrook Plantation. Known as Annandale from 1826 to 2001, Millbrook Plantation's centerpiece is

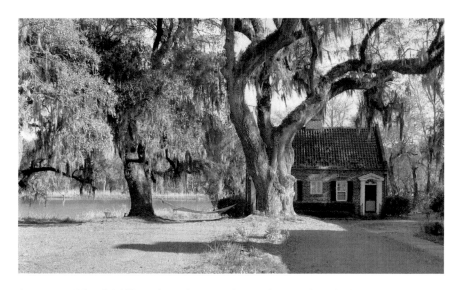

A cottage at Mansfield Plantation, where one thousand acres of antebellum majesty surround guests.

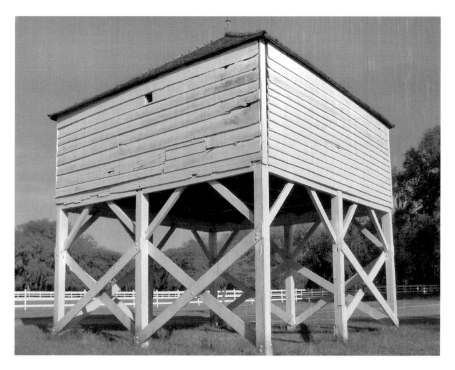

Women dropped raw, husked rice through a hole in this building, and wind blew the chaff away, leaving a mound of pure rice beneath the barn.

a Greek Revival home on the National Register of Historic Places. Such beautiful homes arose during the prosperity attending the rice and indigo cultures. At one time, Georgetown was at the epicenter of world wealth. The world demanded Carolina Gold rice, and vast fortunes were made. To this day, the results of that prosperity grace Georgetown. You'll love the city's oak-tunnel streets and historic homes, each with a plaque visible from the street denoting when it was built. Old gardens, freestanding colonial kitchens and stately homes speak of the elegant life this region knew.

There's much to see. Take, for instance, the Kaminski House (circa 1769). It stands on a bluff overlooking the Sampit River. Deeded to the city in 1972, this beautiful town house overflows with antique furniture and decorative arts such as Charleston-made pieces, a fifteenth-century Spanish wedding chest and a Chippendale dining table. An observation deck overlooks the river.

The city has great restaurants, among them the Rice Paddy, Lands End and Alfresco Georgetown Bistro and its great Italian fare and seafood. It is also home to the Champion Oak, a live oak over five hundred years old with a twenty-three-foot circumference. Take a Swamp Fox tour and take in Georgetown, a jewel of a city deep in rice field country. Charm, beauty, history and great food await you. Enjoy southern culture at its very best in a seaport that may well be the cradle of North America.

If you go:

SWAMP FOX TOURS
843-527-1112
10:00 a.m. to 4:00 p.m. Monday through Saturday
Inquire for fees

GREENVILLE:
A WHITEWATER CITY

Mountains, Games, Balloons and Bistros

A rare sight awaits 104 miles away in the Upstate. Not many cities in the country can boast of whitewater, but Greenville can. Its Reedy River Falls gives the city a cool splash of freshness. Finely drawn filaments of water create an oasis in this Upstate metropolitan area. Whitewater's soothing noise provides an interlude from city clamor, and people enjoy Chattooga-like settings without having to drive into the rugged Northwest Corner.

Greenville's Falls Park and its "Big Brother" waterfall provide a relaxing setting for residents and visitors. Liberty Bridge, a curved suspension footbridge, overhangs Reedy River and its rare urban falls. A single suspension cable supports the bridge, which seems to float from afar. Below the 345-foot bridge is where Greenville's first European settler, Richard Pearis, set his trading post in 1768. You'll find history here, as well as great shops and cafés. A resurgence in the 1990s turned the West End of Greenville into a favored site for the arts, shopping and dining. Bistros, galleries and shops draw visitors and residents to the West End, whose history reaches back to the 1830s.

There's much to see and do here, especially in the spring. May is festival month, and the Upstate has its share. Just minutes from Greenville, Simpsonville's annual Freedom Weekend Aloft takes place on May 24–27. It's an easy eighty-two-mile drive to Simpsonville's Heritage Park, where the largest Memorial Day festival east of the Mississippi showcases hot air balloons, mankind's oldest method of flight. The gas burners roar, and the morning sun renders ascending balloons incandescent. Rising above the Upstate in a gondola

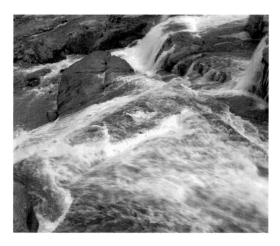

The Reedy River ripples through the heart of Greenville, blessing Falls Park with soothing white noise.

provides stunning views of the Piedmont and Blue Ridge Escarpment.

On May 24–25 at Furman University, the Scottish games, Gallabrae, take place. Greenville has one of the country's highest concentrations of Scots-Irish descendants. Gallabrae features heavy athletic competition events such as the caber toss. This athletic competition developed from the need to toss logs across narrow chasms in order to cross them. The Standing Council of Scottish Chiefs ranks Greenville's games among the top games worldwide.

Spring is a beautiful time to drive through the Upstate. From whitewater to outside dining overlooking the Reedy River to watching strong men in kilts compete, there's much to see. And if you're simply seeking solitude and splendor, you can always drive into the mountains, where the Blue Ridge Escarpment harbors Caesar's Head, Table Rock and majestic waterfalls. Let falling water inspire rising joy. This folded land—cloaked in green and running white with rapids and waterfalls—provides a great stage for exploring, and festivals simply add to the irresistibility of Upstate in the spring.

If you go:

FREEDOM WEEKEND ALOFT
May 25–28
3:00 p.m. to 11:00 p.m.
GATE: *$7.50–$10.00 (12 and under free)*
PARKING: *$5.00 per car, shuttle system included*
Food Vendors
www.aloft.org

HOLY CITY GETAWAY

Walk the City of Steeples

Charleston just has a way of making you feel special. If you're like me, the moment you turn onto Meeting Street, you feel so much better. The everyday world you left behind is just that—behind. A 114-mile drive—that's all it takes to get the feeling you're in Europe.

Walking the Holy City's streets provides a feast for the senses—beautiful buildings, beautiful people, the clop-clop-clop of horse-drawn carriages, restaurants' tantalizing aromas and lilting accents from the world over please the senses. Condé Nast's readers declared Charleston the world's number-one tourist destination in 2012. History, restaurants, churches, old cemeteries and more make the Holy City a favored place. Approximately 5 million tourists visit Charleston each year, and the city serves up delights at every turn.

Charleston even has a fire tower—if you know just where to look. Excuse my long list, but what a list! Walled gardens, sweetgrass baskets, historic venues, the old market, Rainbow Row, cascading fountains, cobblestone streets, sumptuous restaurants, magnificent architecture, the Battery, gallant boutiques, old cannon, tolling bells, gas lamps. And everywhere you look, you see historic societies, preservation societies and related foundations. The past is closely guarded here. And from where does the Holy City get its endearing sobriquet? Majestic steeples. You can't walk fifteen feet without encountering historic markers and plaques. The National Register of Historic Places works overtime here. The list can go on and on, but let's end it with that pleasure known as she-crab soup.

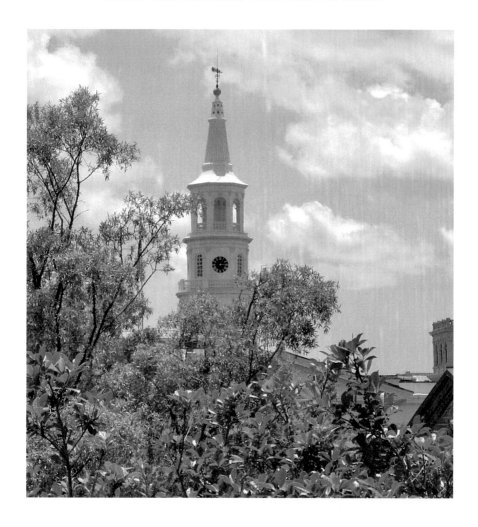

Many southern cities are renowned for their wrought-iron gates (Savannah comes to mind), but Charleston towers over others when it comes to wrought-iron artistry. The incomparable artistry of the late Philip Simmons, a blacksmith, graces the Holy City from one end to the other.

Yes, the city of steeples is a pure delight. The glimmer of gas lamps brings a touch of the 1880s ambience to homes and streets. Something as simple as watermelon-red crepe myrtle blossoms falling onto cobblestone streets says, "You're in Charleston." And what an irony that walking among its hauntingly beautiful old cemeteries makes you feel more alive than ever.

Summer makes for a great time to see this charming shrine of the South. Drive south and walk about. Sure, Rainbow Row gets a lot of glory, but

Above: If you know just where to look, you'll spot this fire tower in downtown Charleston. The bell alerted citizens to hurricanes, fires and national events.

Opposite: The beautiful steeples gracing Charleston's skyline earned it the nickname "Holy City."

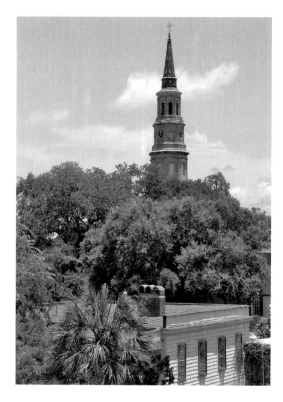

Steeples orient visitors and help them find their way.

other streets have their charm as well. Walk down Queen Street. Looking a bit like Rainbow Row on East Bay Street, it's in the French Quarter and one of Charleston's more photographed venues. Charleston has it all. Add the meticulously preserved architecture of renowned homes and a certain fort in the harbor where a war began, and the Holy City steeps in history. Take a good camera, a keen appetite and comfortable shoes. Walk the Holy City and leave all things ordinary behind.

If you go:

For more information, see the official Charleston Visitor's Guide.

PADDLE WITH THE DOLPHINS

Everybody knows Shem Creek is a popular venue for seafood down Charleston way. The parking lots are always full. It's known too for its picturesque shrimp trawlers. But check out Shem Creek proper, and you'll see it's got more than trawlers and catamarans moored there. You'll see paddlers in brightly colored kayaks gliding by. You'll see intrepid souls paddling by, upright on paddleboards. Well, why not join them and paddle with the dolphins, as a motto for Nature Adventures Outfitters proclaims?

Shem Creek provides a launch point for exploring Charleston Harbor and tidal marshes. Shem Creek gives kayakers a chance to ride the tides and see wildlife, including dolphins. Yes, you literally can paddle with the dolphins. While shorebirds are common, surprises include manatee and sea turtles. Views of man's creations include Castle Pinckney, Patriots Point, the Ravenel Bridge, Fort Sumter and the Sullivan's Island Lighthouse. Don't be surprised if a V of eastern brown pelicans glides right over you. Why? Because kayaking is a stealthy way to observe wildlife. Sitting low in the water, devoid of your human profile, you're at one with nature. No noisy gasoline engine announces your approach, nor do the fumes. You'll catch a lot of wildlife off guard. Paddle quietly and smoothly, and you'll navigate a place flooded with beauty and wildlife. Nature watching is one of the true joys of kayaking. Another perk is exercise.

You'll be in capable hands. Guides know their stuff. Guides are university degreed or are certified master naturalists in biology/ecology and other related fields. They understand, too, the need to protect our environment.

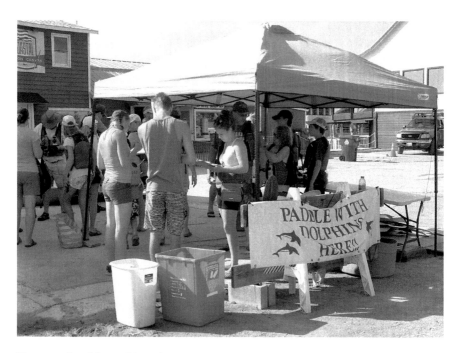

Sign up and paddle out Shem Creek and past restaurant patrons and shrimp trawlers.

Safety is emphasized at all times. Many guides are experienced lifeguards and hold certifications in first aid, CPR and Wilderness First Aid, as well as American Canoe Association and British Canoe Union (kayak) certifications.

Nothing beats a day on the brine seeing classic Charleston landmarks and wildlife to boot. Expect to hear a lot of shouts: "Look at that dolphin!" "Wow, was that a manatee?" Plan a trip when the tide is high to get the biggest bang for your bucks. Walk-up adventurers are welcome, but it's best to plan an excursion before making the 116-mile trip to Shem Creek. Contact Nature Adventure Outfitters and get the details. You can rent kayaks, canoes and paddleboards and explore on your own or book a family tour. Beginners and ages four and up are welcome. The outfitters hold daily tours of two hours, three hours or full-day and overnight expeditions. Check out their website. You can book your adventure online. And if you paddle up a good appetite, you don't have to drive anywhere. Restaurants aplenty surround you.

If you go:

NATURE ADVENTURES OUTFITTERS
483 West Coleman Boulevard
Mount Pleasant, SC 29464
843-568-3222
800-673-0679
www.kayakcharlestonsc.com
nao@att.net

SASSAFRAS MOUNTAIN

Stand atop South Carolina's Rooftop

Feel like a challenge? Drive 134 miles (two hours and twenty-one minutes) to Pickens County and ascend Sassafras Mountain's 3,560 feet—by car, of course. Once at the top, you've reached the highest point in South Carolina—its rooftop. Standing on Sassafras Mountain, you can look over a rippling green land in spring, a darker green in summer and a color-struck land in autumn. I'd avoid it when winter's icy grip holds the land.

South Carolina's rooftop attracts "highpointers," people who pursue the sport of ascending the highest elevation in a given area. As you'd expect, climbing each state's highest point ranks high on the list of highpointers, and this is why they come to South Carolina's rooftop.

I've made it to the top in early morning. At dawn, sun glints off three lakes as the forests of four states mutate from black to olive green to jade. From Sassafras Mountain, you can see the Volunteer, Tar Heel, Peach and Palmetto states. Lakes Jocassee, Keowee and Hartwell look like shiny dimes from 3,564 feet, and they pale silver as the sun climbs.

In summer, the rooftop grows pretty hot. Haze obscures things, and the distant lakes appear ill defined. Atmospheric lines of blue, gray and white air stack along the horizon like lake sediment. One summer day, all that hot air played a trick on me. It created a mirage. A freighter appeared to steam across Lake Keowee toward Jocassee. My Vortex Diamondback 8x42 glasses verified things. The freighter was there, all right, headed for mountain swells. It steamed along but got nowhere, this shimmering ship from the sea that cannot be. In a blink, it disappeared. Gone. I looked through the glasses

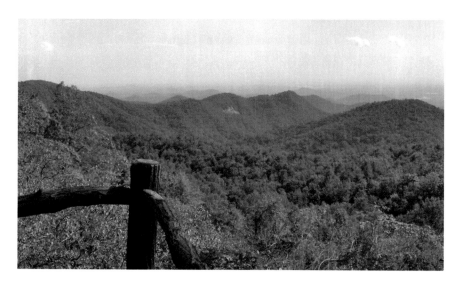

From atop Sassafras Mountain, you can see hazy blue peaks and ridges ripple to the horizon.

again and saw a small watercraft plying the lake's veneer, a feathery wake trailing it. This Fata Morgana brought to mind Hemingway's *True at First Light* and a mirage extraordinaire he witnessed.

> *In Africa, a thing is true at first light and a lie by noon and you have no more respect for it than the lovely, perfect weed-fringed lake you see across the sun-baked salt plain. You have walked across that plain in the morning and you know that no such lake is there. But now it is there absolutely true, beautiful and believable.*

You needn't worry about mirages, and you surely don't have to be a highpointer to go to Sassafras. Strike out. It's a great place to experience other seasons. In August, you can stand atop Sassafras Mountain and feel fall's chill. On Sassafras, a man can see for miles and miles and miles, as Mr. Townsend famously wrote. Standing on South Carolina's rooftop, you look over a rippling green land and smoky blue hills. As night draws nigh, wine, yellow, orange and cinnamon hues prevail until shadows reign supreme.

One final note. A recent South Carolina Geological Survey assessment downgraded Sassafras Mountain to 3,533 feet because of grading that

lowered the natural height. It still stands at least 50 feet higher than nearby Hickorynut Mountain (3,483 feet). (Factoid: Pinnacle Mountain is the highest mountain totally within South Carolina. You'll find it in Table Rock State Park.)

If you go:

SASSAFRAS MOUNTAIN
1399 F. Van Clayton Memorial Highway
Sunset, SC 29685
864-654-1671
LAT/LON: 35.06470°N / 82.7775°W

For more information, visit http://visitpickenscounty.com/vendor/124/ sassafras-mountain.

SHELDON CHURCH RUINS

A Touch of Ancient Rome in the Lowcountry

The South has beautiful ruins. Down in the South Carolina Lowcountry, just off Highway 17 on a route to Yemassee (Sheldon Church Road), stand old ruins that are as good as most Roman ruins—the remnants of Old Sheldon Church. Massive walls flanked by giant columns with a spacious interior attract photographers from all over. Majestic oaks and ancient graves surround the ruins. It's moving to walk the grounds and imagine all that transpired here. Evocative, the ruins are one of South Carolina's more picturesque settings.

You'll find the ruins near Yemassee, which takes its name from the Yemassee Indians. The town is small in size but big in history, and much of that history involved war. As the Civil War wound down, Sherman came through Yemassee on his infamous march to the sea. You'd think places of worship would have been spared, but that wasn't the case. Sherman destroyed all churches in the area except for the Presbyterian church, which the Union army used as a hospital.

Old Sheldon Church, once known as Prince William Parish Church, has been bedeviled by war more than once. Back in the Revolutionary War, Continental troops drilled on church grounds, and Patriots are believed to have stored gunpowder in the church. That was justification enough for British general Augustine Prevost's troops to torch the church in May 1779. The church was rebuilt from its remaining walls in 1826.

Then, thirty-nine years later, General Sherman's Fifteenth Corps under General John Logan burned the church on January 14, 1865. A letter,

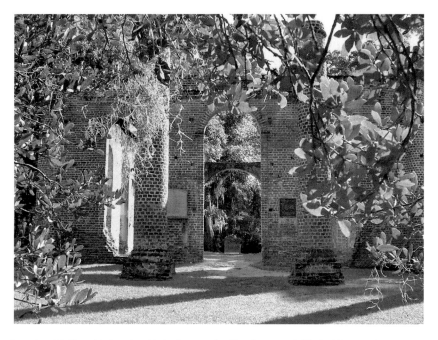

Imagine this fine old church with its floor and ceiling intact and filled with worshipers.

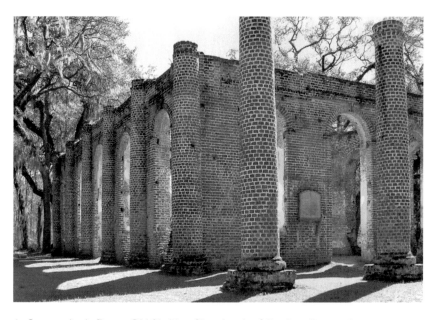

As fine as ruins in Rome, Old Sheldon Church twice fell to invading armies.

however, says Sherman didn't torch the church. After the Civil War, one Milton Leverett wrote, "Sheldon Church not burn't. Just torn up in the inside, but can be repaired." Who or what savaged the church failed to totally destroy it. Once again, the walls refused to fall. One account says area residents gutted the church to rebuild their homes burnt by Sherman. No one bothered to rebuild the church this time, thus do we see the hauntingly beautiful ruins today, which are on the National Register of Historic Places.

Classic in their simplicity, old brick columns stand as monuments to Old Sheldon Church. Built in 1745–55, it's one of the country's first Greek Revival structures. You can still see part of the church's old gate, and an old hand-operated pump near the gate still works. Inside the ruins rest the remains of Colonel William Bull, who helped General Oglethorpe select Savannah's location and layout. If only these old walls could talk.

Long after we're gone, these ruins, like those of ancient Rome, will carry on, causing curiosity seekers, writers and photographers to marvel at what once was but is no more. It's well worth the drive, and Old Sheldon Church Road itself is a trip through time to the South of old. Be sure to take a good camera. Picnic on the grounds, and when you're ready to move on, Beaufort and Savannah aren't that far away.

If you go:

DRIVING DISTANCE: *121 miles*
DRIVING TIME: *One hour and fifty-five minutes*
Old Sheldon Church Road
Yemassee, SC 29945

Ample parking exists across the road from the old church.

STUMPHOUSE
MOUNTAIN TUNNEL

Follow S.C. Highway 28 out of Walhalla into the Appalachian Mountains, and you'll discover a tunnel where men performed backbreaking labor pursuing a railroad dream. You'll also see a beautiful waterfall.

I made the drive north on Highway 28 out of Walhalla early one fall day. I visited Issaqueena Falls and its three stair-stepping cascades in the early morning. The air was cool and crisp. Approaching the falls, I saw water flowing over an edge. At first it was a bit of a disappointment, but then I walked down the trail to the right, and there a treat greeted me. Falling dramatically was Issaqueena Falls, the early light glittering on a filigree of aquamarine water.

A short walk uphill took me to Stumphouse Mountain, where a 1,600-foot tunnel fell short of creating a railway passage from Charleston to Cincinnati. Check out Stumphouse Tunnel, the Upcountry's black hole. Enter its hand-chipped, reverberating, dripping shaft that's 1,617 feet long. It's so dark in there man can't even pipe in daylight. No bats, though—or are there? Enter if you dare.

Irishmen chipped and drilled through solid granite, hoping to link Charleston to the Midwest. It's hard to imagine what difficulties they encountered. Stumphouse Mountain Tunnel reminds us of their failed 1850s attempt to link the port of Charleston to the cities of the Midwest by rail. After six years, the Civil War and a lack of money brought the backbreaking work to a halt. The tunnel had been excavated to a length of 1,617 feet of the planned total of 5,863 feet. Some one hundred years later, Clemson

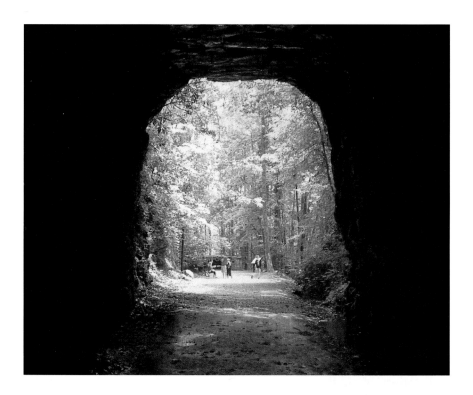

University used the tunnel to age bleu cheese but relocated the operation to air-conditioned cheese-ripening rooms, where it was able to duplicate the conditions indoors—chiefly the 85 percent humidity and constant fifty-six-degree temperature. The tunnel measures 17 feet wide by 25 feet high. About midway through the tunnel, a 16- by 20-foot airshaft shoots 60 feet up to the surface. As a result, a steady breeze flows out of the tunnel. It also leads to condensation, causing the tunnel to be generally wet.

As for Issaqueena Falls and its beautiful two-hundred-foot cascade, legend holds that the Indian maiden Issaqueena rode to a nearby fort to warn of a pending Indian attack and then escaped pursuing Indians by pretending to leap over the falls, under which she actually hid.

The City of Walhalla operates a park at Stumphouse Mountain Tunnel and Issaqueena Falls. The park has picnic facilities, trails and outhouse restrooms. It's open daily from 10:00 a.m. to 5:00 p.m. except on Christmas Day and during inclement weather. Admission is free, but there is a fee to reserve the large picnic shelter. The park does not have camping facilities or drinking water. Camping is available at nearby Oconee State Park, and

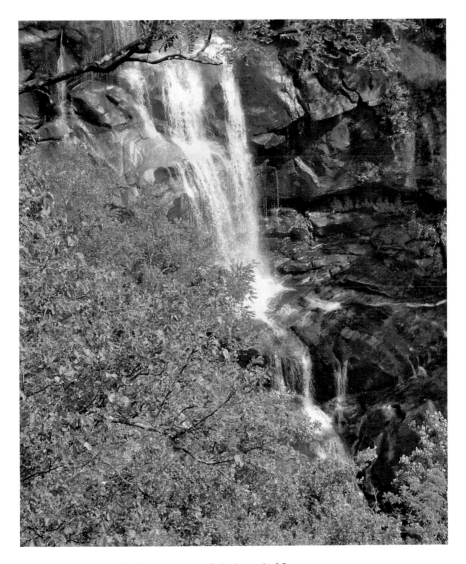

Above: Beneath these falls lies the origin of the legend of Issaqueena.

Opposite: In 1951, Clemson University cured bleu cheese inside Stumphouse Mountain Tunnel. Clemson still owns the tunnel, but the City of Walhalla manages it.

other beautiful falls such as Whitewater Falls are also close by. Make the trip and see the black tunnel and glittering waterfall, studies in contrast that make the park so compelling.

If you go:

It's two hours and twenty-nine minutes to Walhalla (147.0 miles). From Walhalla, drive west on S.C. 28 for 6.9 miles and then turn right into Stumphouse Tunnel Park.
Call 864-638-4343 for more information.
www.oconeecountry.com/stumphouse.html

THE NORTHWEST CORNER

Savor the Green Mountains' Attractions

While the beach grabs a lot of headlines, our Northwest Corner pleases many as a destination, especially when flatter lands bake and sizzle. Not quite three hours and 150 miles will take you from 292 feet above sea level to

The cool, serene northwest corner, where the next bend reveals a stunning overlook.

over 1,000 feet and much cooler air, not to mention spectacular views. Strike out for the mountains. Here are six other reasons to drive northwest.

THE COVE FOREST

Nowhere else in the United States will you find as much tree and plant diversity as you will in a southern mountain cove forest. Green and serene, South Carolina's bowl-shaped valleys are damp and rich with nutrients. The resultant profusion of plants supports birds, amphibians and mammals. There's no need to go to the tropics. Drive to the mountains above Walhalla to see green tropical splendor.

RAM CAT ALLEY IN SENECA

Make the scene Thursday evenings at Ram Cat Alley, a place whose identity began with the cats congregating at the 1908 Fred Hopkins Meat Market. So many cats frequented the alley that someone once said, "You couldn't ram another cat into the alley." Mid-1990s revitalization took an alleyway of pool halls, bars and meat markets and turned it into a pedestrian-friendly area highlighted by boutique shops and restaurants. On Thursdays, restaurants and the city set up tables for "Jazz on the Alley." Dine out in the mountain air and enjoy mountain music that's a bit sophisticated.

MAJESTIC FALLS

Make the hike to Cove Falls; it's a challenging but rewarding journey. You'll find other falls, too, such as beautiful Issaquena Falls just below Stumphouse Mountain, Raven Cliff Falls near Caesars Head and Whitewater Falls near the North Carolina–South Carolina border. Upper Whitewater Falls, near Cashiers, North Carolina, drops over 411 feet, making it the highest falls east

of the Rocky Mountains. Lower Whitewater Falls, located just across the line in South Carolina, drops another 400 feet.

The Foothills Trail

For the hardy, hiking is great in the Northwest Corner. Along the Blue Ridge Escarpment, trails take hikers back to simpler times when pioneers made their way through mountain forests. Then as now, distant views of horizons provided a barometer of how the trails thread through terrain high enough to be moistened by cloud vapors.

South Carolina's Rooftop

Want to go even higher? Atop Sassafras Mountain—South Carolina's rooftop—you can look over a rippling green land and smoky blue hills. As night draws nigh, wine, yellow, orange and cinnamon hues prevail until shadows reign supreme.

A trip to the Northwest Corner is sure to take more than a day. Plan an overnight stay. From rustic lodges to state parks and bed-and-breakfasts, you'll find beautiful accommodations. Take a good pair of binoculars, maps and sturdy walking shoes and beat the heat in the green, rolling Northwest Corner.

If you go:

It's two hours and twenty-nine minutes to Walhalla (147 miles). From there, you can work your way to many waterfalls. For more information, visit www.upcountrysc.com.

THE SWEETGRASS HIGHWAY

Lottie's Great Idea Lives On

Charleston's sweetgrass basket weavers are legendary. They are as much a part of the Lowcountry as she-crab soup, Spanish moss, sea oats and a crashing surf line. Their baskets please the eye with their symmetrical lines and khaki and tan patterns. Sweetgrass grew in popularity at the beginning of the twentieth century, when women in Mount Pleasant began making "show baskets" for tourists. It began with the 1929 opening of the Grace Bridge, which connected Charleston to Mount Pleasant. An idea struck Lottie "Winnee" Moultrie Swinton. She decided to sit in a chair with her baskets along Highway 17. People saw her beautiful work and pulled onto the shoulder of the road, thus giving birth to a tradition. Today, the stretch of Highway 17 near Mount Pleasant is officially designated the Sweetgrass Basket Makers Highway.

Elizabeth Eady, seventy, has been weaving baskets all her life. She says in a matter-of-fact way, "I made my first piece before I went to the first grade." She uses simple implements just as her predecessors did—forks and spoons. "That's the way to go," says Elizabeth. "Break those handles off, file 'em down and start weaving."

Elizabeth and her sister Mabel sit and weave in a stand off 17's inbound lanes to Mount Pleasant. Their voices are soft and their words measured, as if they're timing them to the stitches they make. The women work from 8:30 a.m. to 6:30 p.m. seven days a week, weather permitting.

When they arrive at their stand, they unpack their baskets and hang them with care on nails jutting from the two-by-fours that frame their stand. Stand

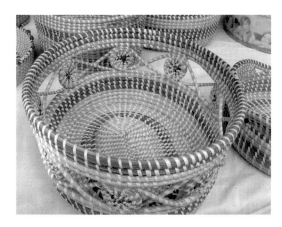

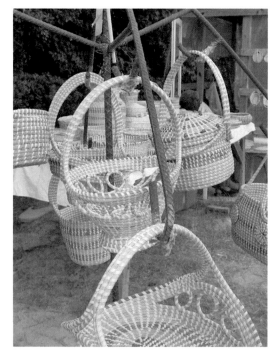

Above: For sale. Just off the shoulder of Highway 17, the Sweetgrass Basket Makers Highway.

Top: The baskets put off a fragrance akin to fresh hay.

downwind of all those baskets, and you'll think you're in the middle of a hay field. "When you clean the baskets, it makes the smell fresh," says Elizabeth. "They'll smell that way all their life."

"Weaving baskets is so hard it'll make you cuss," says Elizabeth. "Damn, this is hard." To this day, the women start over if they make a mistake. "That's how we were taught," says Elizabeth. Once a basket is off to a good start, it becomes a matter of patience, skill and technique passed down from generation to generation. The women sit and weave, working their filed-down spoons. Slowly a work of art forms whose symmetry, precision and alternating colors give sweetgrass baskets their classic appearance.

And what about Elizabeth and Mabel? Well, they have worked all their lives making baskets down by the Sweetgrass Highway just two miles from where they grew up on Hamlin Road. In an era when people jump all over the country like cash-crazy crickets chasing the almighty dollar, these sisters have lived and worked just as their predecessors did. Life would be less beautiful without them. Go see an art

form as old as Africa. It's waiting for you on Highway 17, the Sweetgrass Basket Makers Highway.

If you go:

Sweetgrass Basket Makers Highway begins at the intersection of U.S. 17 and S.C. 517 (Isle of Palms Connector) in Mount Pleasant. It's about 118 miles from Columbia—not quite two hours.

THE SOUTH CAROLINA TOBACCO MUSEUM

Follow the tobacco trail to Mullins, and you'll come to the South Carolina Tobacco Museum in the old downtown depot. There you'll be in good hands when Executive Director Reginald McDaniel leads you on a tour, entertaining you with his knowledge and wit of all things tobacco. "We're a casual museum, and people seem to like that," says McDaniel.

The museum opened in August 1998 as the Mullins Tobacco Farm Life Museum. Per the General Assembly of South Carolina, the museum is now recognized as the official tobacco museum of South Carolina. And what might you see there? A lot. For starters, there's an aged and beautiful dugout cypress canoe with some of the most beautiful wood you'll see. Beautiful also is a humidor for millionaires crafted from Honduran mahogany with inner workings made of eucalyptus and menthol. Definitely worth a sniff!

A one-hundred-plus-year-old barn has been relocated to the museum. Step inside, and experience what pure nicotine smells like. You'll be in for a pleasant surprise. See 1775 china with tobacco leaf motifs. Especially interesting are circa 1700 era pipes made from South Carolina white river clay. See, too, tobacco tags that were once as coveted and collected as baseball and NASCAR cards.

See Strom Thurmond in an old magazine ad for Lucky Strike cigarettes. In the Mullins Room, you can sit in red-striped chairs that came from RJ Reynolds' executive headquarters in Winston-Salem, North Carolina. Sit where millionaires sat. For those of you with a good memory, you'll

Executive Director Reginald McDaniel will tell you all about tobacco.

recognize Perry Mason's secretary, Della Street (Barbara Hale), in an ad for Chesterfield cigarettes.

A kitchen from the tobacco era is re-created in the museum. In that kitchen is a forerunner of sorts of today's hybrid cars, which use two energy sources. See an old oven with a wood-burning side and electric surface side by side. No doubt it was a transition between pure wood-burning stoves and the all-electric ranges sure to come. It still has the original price sticker on it, $425.

"The history of Mullins," says McDaniel, "is the history of tobacco." He's right, and that history has an interesting reach. A local fellow, Jack Rogers, was an auctioneer, and a portion of his "sold American" chant always closed out *Your Hit Parade*, a radio show that crossed over to television.

By conscious decision, the museum will not feature any memorabilia or artifacts that came into existence after 1950. Everything is vintage. Plan your day so you can dine at the nearby Webster Manor (115 East James Street), where the fried chicken, side dishes and desserts are sure to please you. Enjoy classic southern cuisine in this 110-year-old home whose upper story is a bed-and-breakfast. (Here's a hint regarding when to go: Thursdays are "Thanksgiving Days"!)

Visitors from twenty-one countries have visited the tobacco museum. "Foreigners are museum people," notes McDaniel. Well, we're just a day away, not a country away. Make the day trip to Mullins and see the history of tobacco and all its colorful connections. Oh, one more thing. Be sure to ask Reginald McDaniel about the difference between a spittoon and a cuspidor. The answer is southern to the core.

If you go:

118 miles and not quite two hours
Open Monday through Friday from 9:00 a.m. to 5:00 p.m.
800-207-7967
www.mullinssc.us/sctobaccomuseumindex.html

WROUGHT-IRON MAJESTY

Simmons's Majestic Gifts

If you travel 114 miles down I-26 toward Charleston (about one hour and fifty-four minutes), you'll make your way to a posh island community by the name of Daniel Island. This master-planned community is modern, elegant and brimming with great restaurants, shops, parks and trails, which make for a great destination. While there, be sure to visit Philip Simmons Park.

Philip Simmons Park is a good place to stroll and an even better place to learn about the master blacksmith whose work graces many venues in Charleston. Wrought iron is the blacksmith's traditional material of choice. A mixture of nearly pure iron with up to 5 percent slag yields linear fibers that give wrought iron a grain much like wood. It's soft, malleable and, as Philip Simmons discovered, ideal for delicate artwork.

Simmons died in 2009, but his legacy endures. That legacy began on Daniel Island, where he was born. As a kid, Simmons visited blacksmith shops, pipefitters, coppers and other craftsmen. The blacksmith shops captured his heart. He'd stand in the door of the shop and watch the red-hot fire and see sparks flying. "I liked that," he said. A blacksmith let him hold the horse while he was putting the shoe on, turn the hand forge and clean up the shop. "After a while, he learned me names of everything," said Simmons. "If he said, 'Boy, hand me that three-inch swage,' I had to know what he wanted. I learned that way."

Early on, Simmons was shoeing horses and fixing wagons, but people kept telling him companies were forsaking horses for trucks and that blacksmiths

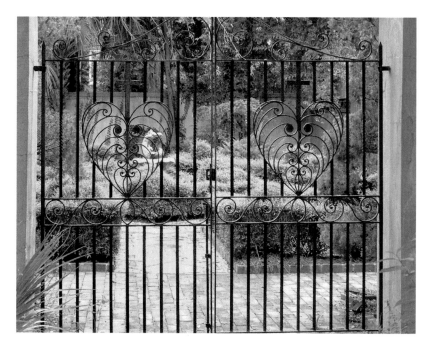

The Double Heart Gate is the entrance to the Simmons Garden from Menotti Street.

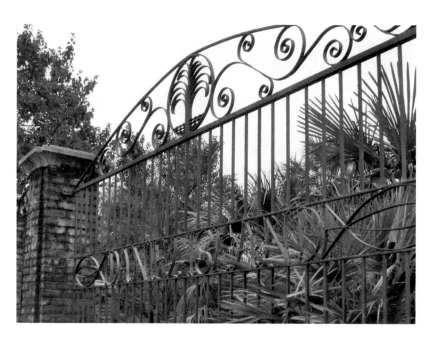

Philip Simmons, the poet of ironwork, was born on Daniel Island.

would go out of business. He turned to gates, fences and window guards. He would go on to fashion more than five hundred decorative pieces of ornamental wrought iron. Simmons could have been content with forging tools for his fellow workers, but he wasn't. He brought a tender touch to the melting of metal and glory to Charleston.

The National Endowment for the Arts bestowed a National Heritage Fellowship upon Simmons in 1982. A blues group sang and played at the ceremony. During his acceptance speech, Simmons said, "My instrument is an anvil. I guess some of you have heard me play…a tune on the anvil, the old blacksmith tune. I'm proud of that anvil, really proud. That anvil fed me when I was hungry, and that anvil clothed me when I was naked. That anvil put shoes on my feet."

Simmons helped make Charleston Charleston, but some of Charleston escapes now and then. Alphonso Brown, who knew Simmons, said, "Some of these homeowners leave Charleston sometimes. I have noticed one thing: when they leave, they take their Philip Simmons gates with them."

You can still view some of Philip Simmons's work that's still in Charleston, such as the "Heart Gate" at St. John's Reformed Episcopal Church at 91 Anson Street.

If you go:

- To see more gates, contact the Historic Charleston Foundation (www.historiccharleston.org).
- To learn more about Philip Simmons, visit www.philipsimmons.us/ index2.html.

A HOP, SKIP AND A JUMP

Day Trips 51 to 100 Miles Away

A PLACE YOU MAY NEVER SEE: THE SAVANNAH RIVER SITE

This day trip might lead to the most interesting place of all for one simple reason: few people are allowed to see it. My history with the place goes back twenty-eight years. One July day in 1986, a self-assigned writing project took me to the Savannah River Site (SRS). And what a site! It covers over 310 square miles.

In building the "bomb plant," the government moved Ellenton lock, stock and barrel—a disruptive event like few others. Way back then, in the early 1950s, a hand-lettered sign at the city limits expressed the evicted peoples' sentiment: "It is hard to understand why our town must be destroyed to make a bomb that will destroy someone else's town that they love as much as we love ours. But we feel that they picked not just the best spot in the U.S., but in the world."

A new town, New Ellenton, was made for the displaced. Many younger residents who left Ellenton, however, never returned. Of those fifty years or older who relocated to New Ellenton, over half died within a decade. Expatriates forbidden to visit their old homes, their will to live withered. Neither were the dead spared, as 150 graves were relocated to a real eternal rest. What about the people from Ellenton who capitulated? In surrendering their town, they saved the homes of people across the world, and the tight security that followed their surrender makes the site a rich and diverse natural area.

Carolina bay wetlands and biological diversity ennoble this place. In a great paradox, a place that refined materials for hydrogen bombs created a

No Trespassing

By Order Of The

United States
Department Of Energy

The Savannah River Site is the largest restricted land area in the eastern United States.

grand oasis home to more than 240 bird species, over 100 species of reptiles and amphibians and nearly 100 species of freshwater fish. A creek coursing through the site exhibits the greatest diversity of invertebrates of any creek in the Western Hemisphere. South Carolina's largest alligator—over thirteen feet long—lived here. As one-time SRS Ecology Lab director Whit Gibbons pointed out in *USA Today*, "These are not nuclear mutants, simply specimens grown large because they are not hunted or fished. It's a pretty simple formula. The best protection for the environment is no people."

SRS will offer twenty-two general driving tours to the public in 2014, giving approximately 1,100 people a chance to see the site. Tour check-in begins at 12:30 p.m. at the Aiken County Applied Research Center, located off Highway 278, near the site's northern boundary. Guests will get a safety briefing, a tour of the Savannah River Ecology Laboratory and a general driving tour of the site. The tour will conclude at approximately 4:30 p.m.

Site tours provide an opportunity for those interested in the Savannah River Site to better understand the Department of Energy's facilities and the workers that changed the face of Aiken, Barnwell and Allendale Counties

and area cities and helped win the Cold War. Guests will also learn about the site's future missions.

Be advised that specific natural areas, however, are not part of the tour. You just can't go to SRS without solid justification, but you can apply for one of the guided tours. You won't see any natural areas though. And if you don't take a tour? As close as you will get is driving through on S.C. Highway 125.

If you want to apply for a tour, visit www.srs.gov/general/tour/public. htm for dates, times and other details. When your tour day comes, drive approximately sixty-five miles east, take I-20 to Aiken and follow Highway 19 to the site.

BRATTONSVILLE AND GLENCAIRN GARDENS

Living History and a Sensory Delight

This seventy-two-mile day trip (approximately seventy-five minutes) is sure to delight history buffs and gardeners. A drive to McConnells is the first stop on this two-venue trip. After a visit to Historic Brattonsville and a sojourn to Revolutionary War times, your next stop is Glencairn Gardens in Rock Hill (thirteen miles). There you will enjoy beautifully landscaped lawns, walkways and year-round flowers.

At Brattonsville, reenactors stage the Battle of Huck's Defeat, a rallying point that eventually led to the King's Mountain victory. Historic Brattonsville, a 775-acre Revolutionary War living history site, also gives you an opportunity to explore the Bratton Plantation. Three generations of Brattons lived there, and it looks much as it did during their time. You won't find barbed-wire or metal post fences on this old farm in York County. You will find split-rail fences that typically didn't need much upkeep, saving farmers valuable time. And you'll find a lot of history.

One of South Carolina's many cultural attractions, Brattonsville celebrates the Bratton family's pioneering spirit, hard work and the sacrifices descendants and slaves made. You'll see surprising sights—a scarecrow, for instance. And the slave cabins here are unique. In the 1800s, most slave cabins were built from logs. John Bratton built his from brick.

Take your time and see how people worked and lived during Revolutionary times. Brattonsville has twenty-nine old structures that were pivotal to farm life. See how backwoods cabins and farm buildings were made from logs chinked with mud. Brattonsville truly is a trip back in time.

Next up, Glencairn Gardens. A thirteen-mile drive northwest from Brattonsville takes you to Rock Hill's Glencairn Gardens. It started as David and Hazel Bigger's 1928 backyard garden and grew into an eleven-acre paradise. A who's who of flowering species airbrushes the garden with tints, tones and hues, thanks to azaleas, camellias, dogwoods, wisteria and more. Glencairn Gardens inspired Rock Hill's annual Come-See-Me festival. For over fifty years, Glencairn Garden has showcased nature's finest colors, textures and shapes. Here you'll find a veterans' garden, tiered fountains, ponds, boardwalks, a stage and a great place to walk flower-filled alleys.

During summer months, the bright crape myrtles provide the perfect backdrop for a picnic. You'll find a bonanza of beautiful plants, including day lilies, annuals, and hostas. The gardens expanded recently. See the tiered fountain and bridge. Other attractions include the Vernon Grant Wall of Whimsy, the Bigger House and more. Pack a picnic lunch and dine amid the beautiful surroundings of David and Hazel Bigger's garden. Once you return home, you have not one but two places to recall. Plan a return to see battle reenactments at Brattonsville and return to Glencairn to see the beauty during other seasons.

If you go:

HISTORIC BRATTONSVILLE
1444 State Road S-46-165
McConnells, SC 29726
803-628-6553
http://chmuseums.org/brattonsville

GLENCAIRN GARDENS
725 Crest Street
Rock Hill SC, 29730
Open daily from dawn until dusk; no admission fee
803-329-5620
http://glencairn.yorkmg.org

CATAWBA POTTERY

Catawba women still make pottery using traditional methods, thereby maintaining a link with their past. Catawba pottery is highly prized. Down Charleston way, some cooks feel that okra soup and other dishes can't be prepared properly without a Catawba pot's slow, steady cooking.

Approximately sixty miles away at 119 South Main Street, you'll find the Native American Studies Center, part of the University of South Carolina–Lancaster. There you'll see beautiful pottery. Established in August 2012, this comprehensive center for the study of South Carolina's Native American peoples offers you the chance to view the single largest collection of Catawba Indian pottery in existence; learn about Native Americans in the Southeast, participate in educational classes and programs in which you can learn about archaeology, language and folklore; and hear oral history in labs.

This area is rich in history. Lancaster and its environs have long been home to the Catawba Indian Nation. They have a reservation here. And they have something else, something special, something the Catawba have kept secret for hundreds of years: sacred clay holes.

Caroleen Sanders is the center's artist in residence. A talented potter, Caroleen's mission is to restore purity to how the Catawba make pottery. (*Catawba*, as you probably know, means "people of the river," and that river, of course, is the Catawba.) According to Caroleen, finding a good seam of clay provides a rush like finding a vein of gold. "Pure clay is blue and won't dissolve," she adds, holding a lump of clay that's soft and satiny smooth.

"The snake wards off insects or whatever might be hungry and trying to get into the food pot."—Caroleen Sanders

When potters go to dig clay, they get into holes where the best clay is six feet down. Standing in a hole, they all but disappear. Once they have a good amount of clay, they cover the hole with brush and straw so interlopers can't easily find it. Several challenges exist regarding the clay holes or pits—snakes, for one. A bigger threat, however, is so cleverly hiding a hole that it's location becomes lost. "Forgetting it's there is a threat," says Caroleen.

Getting the clay is when the real work begins. "The clay has to be cleaned," says Caroleen. And it's not cleaned once but several times. "I pour it through three screens to strain it. In time, it clings to my hands like honey." Caroleen and other skilled potters turn that honey into enduring art.

Drive to Lancaster and see not just hundreds of years of Native American history but the Catawba nation's rare and priceless connection with the land. Chief of the Catawba Nation, William Harris, in addressing the House Interior Appropriations Subcommittee, said, "The tradition of pottery making among the Catawba, unchanged since before recorded history, links the lives of modern Catawba to our ancestors and symbolizes our connection to the earth and to the land and river we love. Like our pottery, the Catawba people have been created from the earth, and have been shaped and fired over time and so have survived many hardships to provide a living testament to our ancestors and to this place we call home."

If you go:

NATIVE AMERICAN STUDIES CENTER
119 South Main Street
Lancaster, SC
803-313-7172
http://usclancaster.sc.edu/nas/index.html

Mondays: by appointment only
Tuesday, Wednesday, Friday and Saturday: 10:00 a.m. to 5:00 p.m.
Thursday: 10:00 a.m. to 7:00 p.m.
Sunday: 1:00 p.m. to 5:00 p.m.

EXPLORE AIKEN

A fifty-seven-mile jaunt to Aiken will usher you into a past where luxury ruled the day. You can tour a classy town and see where wealthy industrialists wintered. In Aiken, you'll find much to see and do. And should you desire, you can check out a splendid hotel, the Willcox Inn. None other than Sir Winston Churchill, the man who rallied Britain against Hitler, stayed there.

Frederick S. Willcox established this fine inn long ago in the last years of the nineteenth century. His inn became a haven for Yankees seeking a warmer clime. Today, it's a sumptuous setting with stonework and rich wood-paneled walls. In the Gilded Age, as the 1920s and '30s were known, Aiken was known as the "Winter Colony." Every fall, well-heeled northerners came by private railcar to Aiken to play polo and golf, race their Thoroughbreds, hunt fox and socialize at high tea, musicals, balls and dinners.

As the Willcox Inn's website says, "Politicians, royalty, and captains of industry often visited the Willcox." The Willcox was said to have had the first bathtub in the South connected with hidden plumbing. Over the years, Andy Williams and Bing Crosby came, as did John Jacob Astor, Harold Vanderbilt and Evelyn Walsh McLean, who owned the Hope diamond. I should let you ladies know that make-up queen Elizabeth Arden graced the hotel as well. As for Franklin D. Roosevelt, legend maintains that he rode his private train to the inn's back door, where he quietly slipped inside. In 1999, Robert Clark and I included the Willcox Inn in our book, *Reflections of South Carolina*. Back in 1997 and 1998, when we were working on that book,

There's much to see and do at Hopelands Gardens.

I never made it inside the Willcox Inn. It took me some seventeen years to finally do that. It will be much sooner when I return.

I like the Willcox Inn, and I recommend you check it out. Use it as a base camp and go exploring. Aiken has a lot to offer. Nearby are Hopelands Gardens, a fourteen-acre estate garden, and Hitchcock Woods, one of the country's largest urban forests. There's a place called the Rye Patch, too, a popular venue for weddings and parties.

Hopelands Gardens features a labyrinth where you can walk and think with a feeling of being lost yet found. It's a wonderful place to meditate. The labyrinth opened on April 17, 2007. It's patterned after a thirteenth-century design in France's Amiens Cathedral. It's forty-five feet in diameter with brick pathways leading to a granite center.

Be sure to see the intersection of Whisky Road and Easy Street, where you'll see one of the country's most photographed road signs. Explore the sandy lanes left unpaved for the Thoroughbred horses that walk them. And check out the Racing Hall of Fame.

Aiken is a beautiful town of live oaks, resurrection ferns, dogwoods, ivy and brick walls. Best of all, it is an easy drive away.

If you go:

- *For more information about the Willcox Inn, visit www.thewillcox.com.*
- *For more information on things to do in Aiken, visit www.cityofaikensc. gov/index.php/visitors.*

FOUR HOLES SWAMP AND FRANCIS BEIDLER FOREST

You can be sure bird-watchers know all about this daytrip destination seventy-five miles away near Harleyville. Make the one-hour-and-twenty-two-minute drive and you'll find the Francis Beidler Forest, and within that forest runs Four Holes Swamp. Despite the name "swamp," Four Holes is a river that runs in a series of interlaced streams that braid themselves into a river that feeds into the Edisto River, the world's largest free-flowing blackwater river.

Four Holes Swamp rises in Calhoun County and runs just sixty-two miles. It's in the Francis Beidler Forest, one of the largest wetland reserves on the East Coast. Over 16,000 acres of bald cypress and tupelo gum swamp—the world's largest stand—and 1,700 acres of old-growth forest remain here, some trees over one thousand years old. Within the forest is an Audubon wildlife sanctuary, the aforementioned Four Holes Swamp, a blackwater creek system. Visit the Audubon Center and Sanctuary at Francis Beidler Forest for educational information on this vital natural area. Audubon has managed this natural area for over forty years, and it is a great place to see how much of our valuable wetlands looked before man altered them. When it's not hunting season, the area is used for natural history education courses conducted by the Audubon Society.

Whether you are an amateur or a veteran bird-watcher, you'll love the sanctuary, which has been designated an Important Bird Area. Approximately 140 bird species nest or migrate through Beidler Forest. One of the feathered stars is the gold and rare prothonotary warbler, which sweetens the

sanctuary's swamp music with its chirpy birdsong. If you see a brilliant flash of yellow-orange among the trees, you've witnessed a prothonotary warbler. Were you to really get lucky, you might catch a glimpse of the majestic painted bunting. Overhead and through the swamp canopy, you might see bald eagles. Other wildlife residents include otters, owls and rare plants such as the dwarf trillium, a flower found nowhere else in South Carolina.

Keep an eye on the weather, and when a few warm days arrive, plan a trip to Francis Beidler Forest and Four Holes Swamp. Take your binoculars, a good camera and a bird guide and strike out. Work on a boardwalk has been underway, and you might be able to walk into the swamp, where you can see and photograph wildlife species such as the anhinga. When complete, the boardwalk will stretch two miles. If it's warm enough, you might see alligators cruising through the water. The good thing about the boardwalk is that it lets you see one-thousand-year-old cypress without getting your feet wet.

In this age of urban sprawl, overdevelopment and adverse land use practices, it's good to see that important natural areas are being kept just that, natural. In the words of naturalists, you'll find a rich biodiversity here, and it's not far away.

If you go:

FRANCIS BEIDLER FOREST
336 Sanctuary Road
Harleyville, SC 29448
843-462-2713
843-462-2150

The Audubon Center charges an eight-dollar adult admission. Children are four dollars.
www.audubon.org/locations/audubon-center-sanctuary-francis-beidler-forest

HARTSVILLE: SIMPLE PLEASURES, NATURAL TREASURES

Nature, History and Culture at Its Pee Dee Finest

In the Pee Dee, you'll find a town where simple pleasures are the best—a taste of artesian water bubbling up from an ancient aquifer at a crisp fifty degrees; a native azalea, its bewitching fragrance sweeter than honeysuckle; and the shimmering blackwater reflections of spring flowers. Hartsville, South Carolina simplicity—revel in it. It's a mere sixty-eight miles away, just an hour and twelve minutes.

This beautiful Pee Dee town, a bed-and-breakfast haven stitched to the South Carolina Cotton Trail, resurrects yesteryear's charm. Faulkner may as well have had Hartsville in mind when he wrote, "The past is not dead. In fact, it's not even past." Hartsville is about simple pleasures of the past. No wonder its homes, history and floral wealth lure wayfarers.

Hartsville covers five square miles, within which man transformed 491 acres of virgin pines into downtown Hartsville. Old Sol rains celestial riches here (there are 115 clear days a year), and all that energy feeds gorgeous greenery. People are fond of saying that Hartsville is a garden with a town in it. Kalmia Gardens is Hartsville's pride and joy. May Roper Coker built the garden in the 1930s. With some hardworking men, a mule and enough sweat to float a steamship, "Miss May" sculpted Kalmia Gardens from "laurel land," embellishing its trails with azaleas, camellias and tea-olives. This arboretum sustains a microcosm of plants extending from the Blue Ridge to the Coastal Plain.

Descend the boardwalk (a total 435 feet) down a bluff through Kalmia Gardens across Black Creek, where tannins steep the water dark as tea. See

profusions of mountain laurel, *Kalmia latifolia*, blizzard the bluff white come May. Journey across the creek, where Segars-McKinnon Heritage Preserve displays copious subtropical vegetation.

Climb the bluff to the Thomas Hart house, built circa 1820 and listed on the National Register of Historic Places. See the museum—a restored post office building also on the NRHP. Learn Sonoco's history and see silver from the Eastern Carolina Silver Company. Yes, silver. (Rumors hint that more millionaires live here per capita than any place in the United States.) "There's this notion millionaires live in mansions and drive big cars," said Kathy Dunlap, the executive director of Hartsville Museum. "They can also live in twenty-year-old homes and drive old cars." Kathy should know. South Carolina's oldest car, the steam-powered Locomobile, sits in the museum. Just outside, native Lawrence Anthony's *The Performance*, a steel sculpture sporting a coppery patina, celebrates the music, dance and drama flourishing in Hartsville's Center Theater.

The good life. That's Hartsville. Nature, history, gardens and art. Home to Coker College and Sonoco. Far from ordinary but close to your wayfaring heart.

If you go:

KALMIA GARDENS OF COKER COLLEGE
1624 West Carolina Avenue
Hartsville, SC
843-383-8145
www.kalmiagardens.org
Open dawn to dusk, year-round
Approximately 6.0 miles of interconnecting trails
No fee

From downtown Hartsville, drive 2.6 miles west on Business 151. The third entrance on the right leads directly to the parking area.

HISTORIC ABBEVILLE

Where the Confederacy's Hope Ended

You don't have to go to Gettysburg to see Civil War history. A ninety-five-mile, one-hour-and-fifty-one-minute drive to Abbeville will lead you to a place where many say the Civil War began and ended. The Burt-Stark Mansion is Abbeville's historical and architectural jewel. Known also as the Armistead Burt House, it's the place where the last Council of War cabinet members of the Confederate government met.

Abbeville is often referred to as the birthplace and deathbed of the Confederacy. The birth took place at Secession Hill when local citizens gathered on November 22, 1860, to adopt the ordinance of South Carolina's secession from the Union. Four and a half years later, the Burt-Stark Mansion is where the will to fight left the Confederacy's leaders.

David Lesly, a prominent lawyer and planter, built this fine old mansion as a town house for his wife, Louisa, circa 1840. It was built in the Greek Revival style meant to impress and provide comfort. After Lesly died in 1855, the house went through several owners. In the spring of 1862, Armistead Burt purchased the house. Burt, a lawyer, planter and congressman, had been friends with Jefferson Davis in Washington, D.C. That friendship brought a most historic event to Abbeville.

Historian and tour guide Fred Lewis gives an account of the key moment at the Burt-Stark Mansion:

> *As the Civil War approached its end, President Davis left Richmond, Virginia, on April 2, 1865, heading southwest. He reached Chester, where*

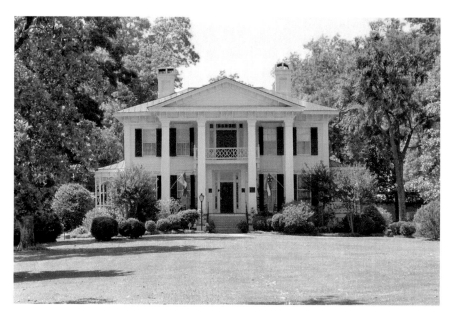

The Burt-Stark Mansion, where Jefferson Davis lost all hope.

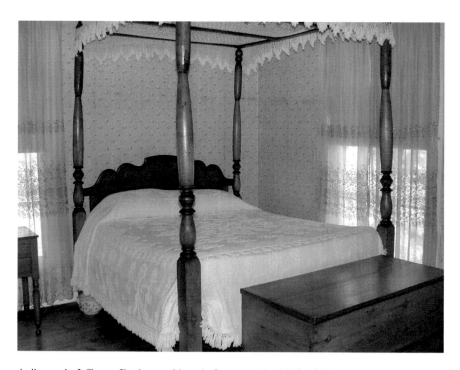

A distraught Jefferson Davis rested here before resuming his fateful journey.

he was invited to Burt's home for a time of rest. He arrived in Abbeville on May 2 accompanied by 900 to 2,000 Confederates. He arrived at the old home around ten o'clock in the morning. After "supper" that evening, he met with Secretary of War John C. Breckenridge, military advisor Braxton Bragg and five field commanders in the men's parlor. His attempt to obtain support for another effort against the Union failed. Convinced not to pursue a guerilla war against the Union, Davis said, "Then all is lost," and the CSA died. Reportedly, a shaken Davis had to be helped upstairs, where he rested in a four-poster bed. Contrary to legend, Davis did not spend the night here.

You can tour the home and see the very parlor where the Confederacy's hopes were dashed and the bed where Davis contemplated all that had happened. For those who love history, architecture and antiques, this southern home is a must see. Authentic antebellum pieces fill the home. The grounds are splendid and have been referred to as a horticultural feast. See the old home's kitchen out back. Get a close look at what a kitchen of the early 1800s looked like. Best of all, see where history took place.

Abbeville is a beautiful southern town. The town has a charming square with restaurants and more, and the drive there takes you through rustic countryside.

If you go:

BURT-STARK MANSION
400 North Main/S.C. Highway 28 Business
Abbeville, SC 29620
864-366-0166
www.burt-stark.com
Ten dollars per person for a one-hour tour

HISTORIC EDGEFIELD

Home to Ten Governors

You'll find a rich history in a town that can boast it's the home to ten governors, a historic pottery tradition, beautiful cemeteries and strange-but-colorful turkey art. We're talking Edgefield, where the statue of Strom Thurmond overlooks the town square. You'll see classic antebellum homes, antique shops, an old carpenter's stand, majestic old cemeteries and lots of history. Just outside the town limits, you'll find the headquarters of the National Wild Turkey Federation.

Founded in 1785 as a trade center for farmers, Edgefield went on to develop some famous native sons. Its ten governors are Andrew Pickens, George McDuffie, Pierce Mason Butler, James H. Hammond, Francis W. Pickens, Milledge Luke Bonham, John C. Sheppard, Benjamin R. Tillman, John Gary Evans and J. Strom Thurmond. W.W. Ball, author of *The State That Forgot*, notes, "Edgefield has had more dashing, brilliant, romantic figures, statesmen, orators, soldiers, adventurers, and daredevils than any other county of South Carolina, if not any rural county in America."

Politics and pottery—that's Edgefield. With its rich resources of kaolin, sands, feldspars and pines, it's not surprising that a pottery tradition has long flourished in Edgefield. Edgefield pottery's history is a good one. Plantations here led to a demand for large-scale food storage and preservation. In the 1800s, slaves made alkaline-glazed, traditional pottery much as they had in Africa. Particularly notable were the "grotesques" or "voodoo jugs" upon which slave potters applied facial features.

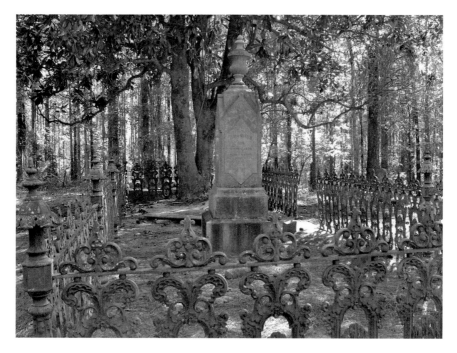

Edgefield possesses a rich history. Explore its cemeteries, and you'll see famous names.

The pottery tradition is alive. Jane Bess, a Charleston native and University of Georgia graduate, makes gorgeous, functional stoneware. In a historic brick building (circa 1918) just off Main Street, you'll find her charming shop and studio.

Edgefield's most famous potter, Dave, was born around 1800. Dave left thirty years of verified work, from 1834 to 1864. In 1840, Dave began signing his work, not by merely stamping his initials on the base, as was the custom, but by writing "Dave" on the shoulder of most vessels. His jars and jugs provide a glimpse into life back then. On one piece, Dave inscribed, "I wonder where is all my relations / Friendship to all and every nation." This couplet, inscribed on April 16, 1857, alludes to the buying and selling of slave family members. On another piece, dated August 7, 1860, he wrote, "I saw a leopard and a lion's face / then I felt the need of grace." Perhaps this references the Bible, a dream or stories passed down by African ancestors. Historians surmise that Dave learned to read and write while working as a typesetter for an owner, Abner Landrum, who published the *Edgefield Hive* newspaper.

Enjoy a day trip to Edgefield. It's not that far away from you, and it's a great place to just walk around. Ask locals about Horn's Creek Church, located down a dirt road, and its hand-painted angels in each corner of the ceiling.

Edgefield—it's worth the drive. Plan a trip when the peach trees are blooming and breathtaking beauty will be your companion.

If you go:

For more information, visit www.exploreedgefield.com.

LANDSFORD CANAL

Rare Flowers and Elegant Stonework

Up Chester County way, Landsford Canal is so beautiful that it ended up in a coffee table book, *Reflections of South Carolina* (Clark and Poland). You could say it's as pretty as a picture. Getting to the canal is easy. It's an approximately sixty-three-mile drive, about an hour. Go visit Landsford Canal State Park and the Catawba River, all blue and rocky, which was once an avenue of commerce.

The locks at the south end of Landsford Canal remind us that man can make beautiful structures from rocks. Irish masons crafted the canal's guard lock, a structure that lowered boats into the canal during floods. The precisely cut granite stones still stand, but now lush greenery grows between them where water once stood. In the river, an old diversion dam of rock continues its prolonged tumble. It's as if time stand stills while this old wall decides whether it's going to fall. Men built this diversion dam to direct water into the canal and to offer riverboat pilots a haven during floods.

People come to the canal all day, especially in May and June, when the rocky shoals spider lilies burst into dazzling white blooms. Anchored among rocks, the flowers festoon the river. You can see the earth's true colors in the river and its load of jammed logs: blue, brown, green and white. One of the world's largest stands of these exquisite white flowers lives here. This plant has adapted to a very harsh environment and puts on one of the greatest natural "shows" on the East Coast. During their peak bloom from about mid-May to mid-June, these plants blanket the river in white blossoms. Their needs are simple: swift, shallow water and

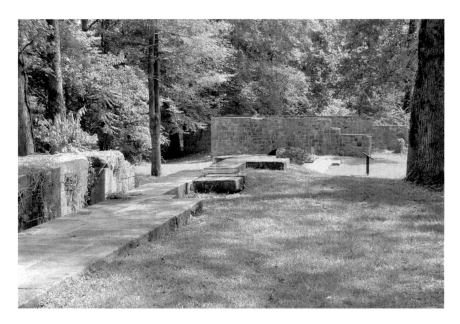

Handsome stonework made Landsford Canal long lasting and lovely.

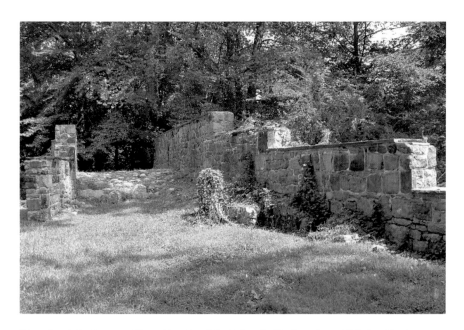

Though subtle, the stones' hues bless Landsford Canal with the colors of Mother Earth.

sunlight. But therein lies a problem. Man's penchant for damming rivers leaves them few places to grow.

Riverboat pilots used to ply the Catawba's waters, but no more. Now kayakers do. Watch folks kayak by, deftly avoiding rocks. On land and by water, people come here to marvel at the old canal. These venerable stone structures stand as monuments to workers who toiled long and hard in the days before power and pneumatic tools came along. And yet their work does more than just endure; it gives us places of stone-cold beauty where we can escape our modern, monotonous version of civilization.

Fishing, boating and nature watching are fine activities to enjoy. Playground equipment is on hand for kids. Hike the interpretive trails and see the foundations of an early 1800s mill site. Pack a picnic and enjoy it at a shelter. Spend time in the museum, housed in a restored Great Falls Canal lock keeper's house, and check out its pictorial displays. (The museum is open by appointment only; call to schedule a visit.) You will love every minute of your visit. Keep an eye out for bald eagles, and best of all, go when the rocky shoals spider lilies are in bloom from mid-May to mid-June.

If you go:

2051 Park Drive
Catawba, SC 29704
803-789-5800
landsfordcanal@scprt.com

Learn more about the park at www.southcarolinaparks.com/landsfordcanal/ introduction.aspx.

McCORMICK: CYRUS'S DREAM TOWN

Where Gold Lies Beneath the Streets

McCormick was home to the second-richest vein of gold discovered in South Carolina. In February 1852, William Burkhalter Dorn discovered gold on the site of present-day McCormick. The Dorn Gold Mine is one of the more important gold mines in South Carolina. Dorn excavated close to $1 million in gold before the mine ran out in the late 1850s. He became wealthy but lost much of his fortune after the Civil War.

Cyrus H. McCormick, inventor of the mechanical reaper, bought the property. When the mines didn't pan out, McCormick planned a town that took his name. That town is one hour and thirty-three minutes away, about eighty miles. Evidence of boom times remains. McCormick has a historic mill, a grand courthouse and a fine old hotel that once housed train travelers. The Dorn Mill, restored in 1973, is one of the few remaining gristmills of its type in the United States. The three-story building, built circa 1898, has two steam boilers that powered two ten-ton stationary steam engines. Inside is a boiler made by Lombard Iron Works of Augusta. That boiler powered this attrition mill, where grinding plates revolved in opposite directions at 2,200 revolutions per minute. When this mill was up and running, the din must have been unbelievable. A beautiful aspect of the old mill is its many hues of wood. Beams, chutes and railings are blond, red and tan. Beautiful, too, is the Silver Creek Flour Packer.

When viewed from the front, the mill has a medieval look. Listed on the National Register of Historic Places, it's lauded as an outstanding example

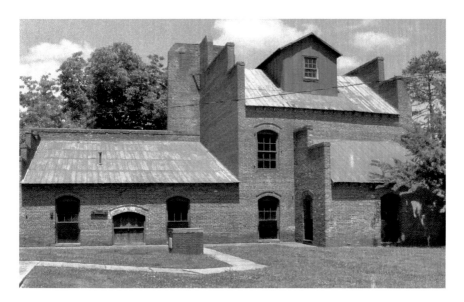

The Dorn Grist Mill, a touch Gothic, brings to mind a fortress or early outpost.

of rural industrial architecture. The dominant feature of the exterior is a three-story brick wall built in 1915 to support a water tower tank.

Hotel Keturah, circa 1910, a building also on the National Register of Historic Places, faces the railroad tracks running through town. In front of the hotel, you'll see six stones sunk into a sloping shoulder of grass just off the rail tracks. Down these "steps," black gentlemen in tuxedoes escorted train passengers to Hotel Keturah. Keturah, by the way, is the name of the wife of W.J. Conner. And who might he be? The man who built not one but two hotels on this site and named them both in his wife's honor. (The first Hotel Keturah, built in 1900, burned in 1909.)

Just beyond Hotel Keturah stands the handsome seat of justice. At 133 South Mine Street stands a historic building. Built in 1923, seven years after McCormick County was formed, the building is a neoclassical style brick building. The interior features pressed metal ceilings and the original transoms and doors. Like the gristmill and Hotel Keturah, it, too, is on the National Register of Historic Places.

Gold, a famous inventor and historic buildings wait in McCormick. And there's a mighty big lake over that way with several state parks. McCormick makes for a great getaway, and it's only a day trip away.

If you go:

MCCORMICK CHAMBER OF COMMERCE
864-852-2382
http://mccormickscchamber.org/attractions.php?silverheader=2#

BAKER CREEK STATE PARK
864-443-2457

HICKORY KNOB STATE PARK
864-391-2450

OLD FRENCH HUGUENOT COUNTRY

Her sun went down while it was yet day.

This day trip is hard to estimate because addresses don't exist, but one hundred miles seems reasonable. Beyond McCormick toward the Georgia line, you'll find old French Huguenot Country. (Main directions below.) Off U.S. 378, your first stop is Badwell Cemetery. Stay on the Huguenot Parkway all the way through Savannah Lakes, and you will spot the Badwell Cemetery road to the right. Take this sandy lane and, after taking the left fork, you'll arrive at a turnaround where a white monument breaks through the greenery. Park near a beech tree where countless souls have carved sentiment and messages into its aged bark.

You'll find the cemetery downhill. Be alert. Legend says a troll guards Badwell Cemetery. A rock wall, partially caved in, protects the cemetery—or tries to. Thieves made off with the Grim Reaper sculpture that guarded the wall's iron door, but it was later recovered and now sits in the South Carolina State Museum. I'll always remember this graveyard, but not because notable French Huguenots such as the Reverend Gene Louis Gibert and Petigru and Alston family members lie here. No, credit for this bittersweet memory goes to the inscription on a four-sided white marble marker:

Not easy to find but worth the effort to see this vanquished place of worship.

Sacred to the memory of Martha Petigru, Only daughter and last remaining child of Thomas and Mary Lynn Petigru, Aged 25 years, 1 month, and 16 Days.

Her sun went down
While it was yet day.

Born Septr. 16th 1830
Died Novr. 2nd 1855

May the parents who bitterly mourn the
Irreparable loss of one
So deservedly beloved,
Be cheered by Him, Who has said,
"I am the Resurrection and the Life,
He that believeth in me, though he were dead,
Yet shall he live."

If you backtrack and take the right fork, you can follow a path to an old block springhouse where folks stored food in cool water to better preserve it.

Your next stop is a memorial to the site of a Huguenot place of worship. Now here you'll have to be a bit adventurous and just drive on past the road that took you to Badwell. Follow the memorial signs. Take a sandy lane to the left and drive through the pines until you see a Maltese cross that marks the spot of the New Bordeaux Huguenot place of worship. New Bordeaux, 1764, was the last of seven French Huguenot colonies founded in South Carolina. The village prospered in the 1760s and early 1770s, but the Revolutionary War ruined the economy, and New Bordeaux faded away.

In addition to Badwell Cemetery, the old springhouse and New Bordeaux, you can also explore Mount Carmel, a ghost town of sorts; the old Calhoun Mill; and the ruins of Fort Charlotte.

Get a good map and strike out on an adventure in history.

If you go:

Drive west on U.S. 378 and then, after passing the Baker Creek State Park sign, look for Huguenot Parkway and follow the signs.
ADMISSION: A bit of courage!

PARSON'S MOUNTAIN LAKE RECREATION AREA

In Long Cane, you'll see a geographic anomaly that revives memories of Oconee and Pickens County vistas. Parson's Mountain, a rocky hill, sits alone overlooking the forest as it stretches to the horizon. Geologists call this type of hill a "monadnock," which is a technical term for a mound of hard rock left when all the surrounding land erodes away. It towers 832 feet over the Sumter National Forest. It's a tough, winding climb to the top, but worth it. Peering through the green canopy of broad-leaved, deciduous trees, the earth drops away into blue haze. It's especially beautiful when fall colors arrive.

Feel up to a challenging climb? Dreams of El Dorado died on this rugged mountain. Take the spur branches off the westernmost portion of the trail, and you will climb past Civil War–era gold mines to the summit. I made the climb. Up top are a fire tower and an arrangement of stones that appear to be a compass. You'll find an upright toilet in the woods just behind the tower. Use at your own risk.

Growling engine sounds float up through the canopy, as more than twelve miles of off-road trails crisscross the mountain's flanks. Come fall, fluorescent orange dots the greenery along the Morrow Bridge and Midway Seasonal Camps as hunters arise and go forth.

From the top of the mountain, you get a great view of the mixed pine and hardwood forests of the Piedmont. It's quiet atop Parson's Mountain, though a diamondback rattler rustled tall grasses right by the trail leading to the top. My walk down was much faster.

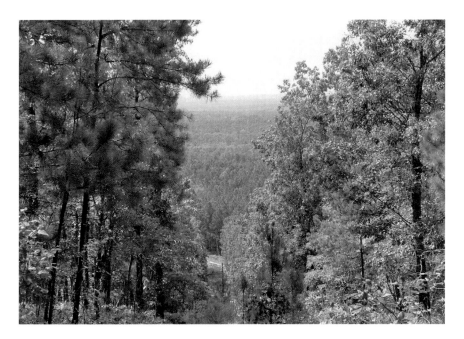

Parson's Mountain will make you think you're in the Blue Ridge Mountains.

Nearby is the Parson's Mountain Lake Recreation Area. A calm, twenty-eight-acre man-made lake distinguishes the wooded land. It's a picturesque area with a twenty-three-acre campground devoted to tent and trailer camping. People like to hike and fish here. Fishermen come here to catch bass, crappie, bream and catfish. Wading birds, including great blue heron, frequent the lake. A good-size picnic area sits near a swimming area (no lifeguards on duty).

The area offers relaxation and solitude as well as easy access to a variety of recreation activities. The day-use area was designed with an earthen pier, a pedestrian bridge and a boat ramp for non-motorized boats.

Before you go, inquire to see if the area is open. It's open seasonally from May 1 through November 15. Even if the area is closed, it's worth the drive to see how Parson's Mountain rises above the land, a mountain seemingly left behind by the Blue Ridge Mountains.

If you go:

454 Parson's Mountain Road
Abbeville, SC 29620
864-446-2273

*Take Highway 34 and enjoy the back-road drive. A ninety-nine-mile drive
in all, the trip is not quite two hours.*
Open from 9:00 a.m. to 9:00 p.m. during daylight saving time
Three-dollar-a-day use fee per vehicle.
Seven dollars per campsite per night
Self-serve fee station
Campsites are first come, first served

GPS COORDINATES: 33.80497, -81.931278

For more information,
visit www.fs.usda.gov/recarea/scnfs/recarea/?recid=47187.

PEACH COUNTRY

You'll Pluck More than Peaches

Down toward Edgefield, you'll find a place Van Gogh would have loved—South Carolina peach country. Van Gogh found a sense of renewal in the peach tree's delicate blossoms, and so will you. Feeling plucky? Then make your way to Highway 23, which threads through acres of peach trees that surely would delight the legendary artist. That little highway will take you through Ridge Spring, Ward and Johnston and out toward Edgefield, where you'll find expanses of pink peach orchards blooming—as well as other things that start with "P."

When a carpet of pink cloaks the sandy hills, you'll see a sight that has seduced many a photographer. Watch the farm reports so you can catch the orchards in full bloom and later make a return trip to get split-oak baskets filled with sweet Carolina sunshine—a treat hard to resist. (The split-oak baskets will come in handy.) In 1984, the peach became South Carolina's official fruit, and with good reason. A tree-ripened peach may well be the greatest-tasting fruit of all. Loving care attends this state fruit. When peaches turn a creamy yellow, they're tender and easily bruised, so hands, not machines, have to do the plucking. Soon you'll see "Peaches for Sale" signs and trucks loaded with baskets of peaches.

Your journey will take you through Ward, where you'll spot an exceptional cemetery beside Spann Methodist Church. The church had its start around 1805 as part of the plantation of John Spann Jr. The cemetery came to be in 1840.

Ward's founder, Clinton Ward; his wife, Martha; and their only child, Josephine, rest here. A sculpture of Josephine stands atop her monument.

A tree heavy with drupes, for that's what a peach is. Next? Pies and ice cream.

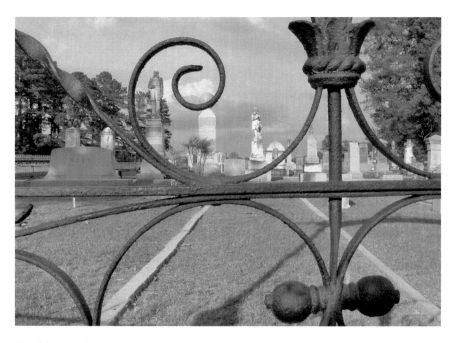

The Ward family plot is among the many fascinating graves in the Spann Methodist Church Cemetery.

She died at age six. A sculpture of Ward, with his period-vogue lamb chops, stands atop a tall monument, but Martha merely has a large sphere atop hers. See the cast-iron statue of a deer at the cemetery gate. The statue of a dog by a tree stands near the railroad track. Ward's marker, Josephine's marker, the deer and the dog made the Smithsonian's Inventory of American Sculpture. The church and its cemetery made the National Register of Historic Places. It's not your ordinary graveyard, nor is this your ordinary day trip.

Travel on to Edgefield, the home of ten governors, and you'll spot artsy turkeys at street corners. (Edgefield is home to the National Wild Turkey Federation.) The ten governors are Andrew Pickens, George McDuffie, Pierce Mason Butler, James H. Hammond, Francis W. Pickens, Milledge Luke Bonham, John C. Sheppard, Benjamin R. Tillman, John Gary Evans and J. Strom Thurmond. Edgefield has a history of potters, too. Plantations led to a demand for large-scale food storage and preservation. In the 1800s, slaves made alkaline-glazed, traditional pottery as they had in Africa. Notable were the "grotesques" or "voodoo jugs" upon which slave potters applied facial features.

Peaches, politicians and pottery make for a pleasant trip. That's what a day trip to Peach Country delivers, and spring and early summer are sublime times to go.

If you go:

This trip is fifty-three miles, less than an hour. Make the trip as long as you like exploring peach country. Take a camera, a healthy appetite for fresh peaches and an appreciation for history.

SOUTHERN ART IN SOUTHERN SCANDINAVIA

A fifty-one-mile drive to our southern Scandinavia takes just one hour and six minutes. Make your way to U.S. Highway 321, and you'll come to Norway, Sweden and Denmark. In Denmark, look for the brick building with the "Drink Coca-Cola" mural at the intersection of Highways 321 and 78. Go inside, and you'll see a beautiful gallery of Lowcountry art. That's where artist Jim Harrison works.

Jim's images capture and celebrate the South and rural America, and they especially chronicle earlier twentieth-century rural life. You'll love his railroad stations, churches, one-room schoolhouses, country stores, covered bridges and farm buildings. You'll also love the realism of his landscapes, where fields of cotton and old barns live. I love his old country stores with Coca-Cola signs. Anyone who loves the Lowcountry is sure to appreciate his coastal landscapes.

Jim has worked more than thirty-five years as a full-time artist, and quite an artist he is. You owe it to yourself to check out his Denmark studio. It's quite an experience to see him work. He's a friendly fellow and is easy to talk to. Of course, he may or may not come out to greet you. Artists need solitude.

Nostalgic for the old days? See Jim's art. It's said that Jim Harrison's America is the America to which we all want to return. His paintings of farm landscapes, country stores and small-town architecture give us all a chance to "go home" again. Jim's art and writing place him among the nation's most important chroniclers of earlier twentieth-century rural life.

Jim Harrison, artist and writer, was born in his grandmother's house in Leslie, Georgia.

Jim Harrison's journey as an artist began when he first climbed onto a sign painter's scaffold on the side of McCartha's Hardware in Denmark, South Carolina. The Coca-Cola sign that he began that day with his mentor, J.J. Cornforth, led to more than one hundred similar signs over the next few years. It pointed the direction he was to go and shaped the future work of this South Carolinian in many ways.

Lately, he's felt the urge to go in new directions, and we will see what great new southern art he paints. For now, let your journey take you to Denmark down in South Carolina's version of Scandinavia. Jim's gallery features original paintings and prints from his long and fruitful career as an artist. See a true southern artist and his work down in South Carolina's version of the Land of the Midnight Sun.

If you go:

http://jimharrison.com/theart/
Call 800-793-5796 for more information.

THE FRESHWATER COAST

Parks, History and More

South Carolina has two coasts—the famous one along the Atlantic and a surprising freshwater coast along the Georgia line, just eighty miles away. You'll find lots of water to the west and some wonderful state parks. To get there, you'll negotiate back roads and state highways that take you through some beautiful countryside. Let the journey be part of the destination.

We seldom think of our freshwater coast. It's there, though. The Chattooga and Tugaloo Rivers, Lake Hartwell and Clark Hill Lake create an unbroken water wonderland from Modoc to Mountain Rest. The waters run the gamut from whitewater to pools, tributaries, rivulets and impoundments. One major impoundment, Clark Hill, is the third-largest man-made impoundment east of the Mississippi River. It and the surrounding area are today's destination.

Fishing, swimming and just floating on Clark Hill Lake entertain many a family come summer. Known to South Carolinians as Lake Thurmond, the lake's traditional name is Clark Hill. Along its Palmetto State shores are several state parks: Calhoun Falls State Park, Hickory Knob, Baker Creek and Hamilton Branch Park. Just across the Georgia line is Elijah Clark State Park.

You'll find plenty to do. The area offers ample opportunity to view wildlife. Osprey and bald eagles wheel above, and don't be surprised if you see seagulls, too. Apparently they like the freshwater coast as well.

Hickory Knob State Park provides the opportunity to golf along lakeshores. And then there's the nearby Little River Blueway, which bills itself as the "Wild Side of South Carolina." Over in McCormick County, Kirk Smith of Outdoor Initiative knows that people like the lake and

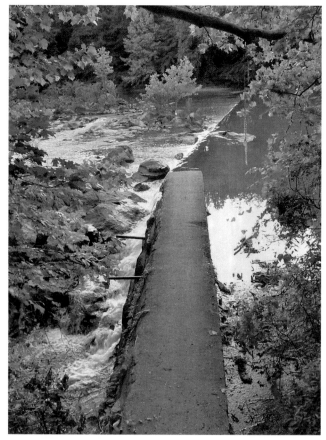

Above: Three massive dams tame the Savannah River, creating large man-made lakes along the Freshwater Coast. Here we see the Richard B. Russell Dam.

Left: An old millrace creates a waterfall on Little River.

Blueway for reasons that aren't always obvious. Take mountain biking, for instance. The *Wall Street Journal* highlighted the Little River Blueway Adventure Area's Forks Area Trail System as one of only two flow trails east of the Mississippi and the only trail in the Southeast. The Blueway offers bikers 156 miles of single track.

The freshwater coast is a great place to visit. It has rapids, hundreds of beautiful campsites, skeet shooting and numerous historical sites. The Blueway even has a scenic fifty-mile drive that takes you through the Heritage Corridor and Scenic Savannah River Highways, country roads and unpaved forest service roads. You'll cross a few single-lane, steel-covered bridges along the way, throwbacks to the 1930s. The drive will take you by several historical sites, including the Long Cane Massacre Site, Badwell Cemetery, the Huguenot Worship Site and the Willington History Center, to name a few.

History, beauty, wildlife, outdoor recreation and more are yours if you head west to South Carolina's freshwater coast. Escape the other coast's clamoring crowds and congestion and enjoy serenity in a place where you set the pace.

If you go:

SOUTH CAROLINA PARKS, RECREATION AND TOURISM
803-734-0156
www.southcarolinaparks.com

ELIJAH CLARK STATE PARK
Lincolnton, Georgia
706-359-3458
www.gastateparks.org/ElijahClark

THE GLENDALE RUINS

Just one hour and thirty-two minutes away (about ninety-six miles) in Spartanburg County stand the beautiful Glendale ruins. Ruins send a troubling message: "Take heed. Here is where grand ideas and mighty events came to pass, but not so mighty as to prevent our destruction." Such was the case with Spartanburg's Glendale Mill, which burned on Sunday, March 21, 2004. Now ruins tower over Lawson's Fork Creek, whose abruptly dropping waters attracted the old mill in the first place.

The ruins, described often as Gothic, loom over people who come to the creek to relax and fish. Occasionally a kayaker comes through. People walk the graveled path through the ruins and climb the bluff overlooking the creek. Behind the Glendale Environmental Studies Center, a Bartram garden grows native species only, and a rock amphitheater brings a tiny Stonehenge to mind. From tragedy comes a measure of triumph.

Rushing past mill villages, old bridge abutments and railroad trestles, Lawson's Fork Creek makes its way to the Pacolet. Whitewater ripples and burbles in the shadows of the ruins of Glendale, which stand over the area like sentries. And what secrets these ruins harbor! During the Civil War, the Glendale Mill made shoe soles and cloth for the Confederacy. Long before that, Native American hunting parties pursued abundant wildlife here. Whether you are an amateur or a veteran bird-watcher, you'll love the sanctuary, which has been designated an Important Bird Area.

To walk across the old steel bridge is to walk into the past. Evocative of a setting in *Fried Green Tomatoes*, this Pratt truss–style bridge commands

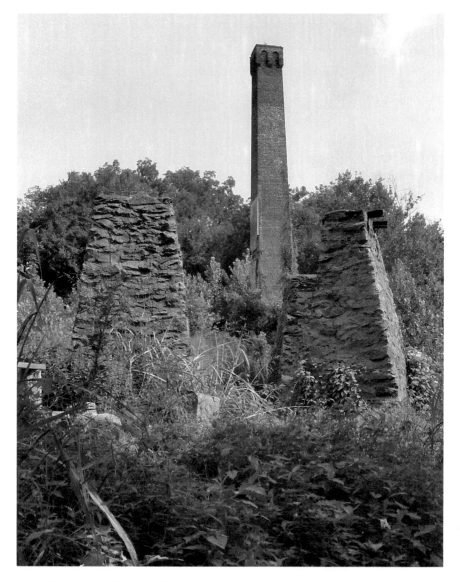

Above: The ruins of Glendale offer haunting reminders that man's dreams often fail.

Opposite: Evocative of a 1930s movie setting, the bridge at Glendale provides a picturesque touch.

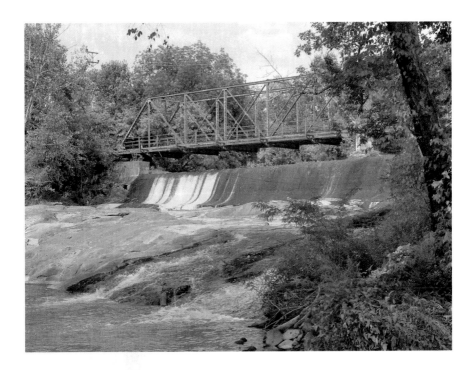

a view of the Glendale ruins. Spartanburg County owns the bridge, which is part of the Glendale Shoals Preserve, a trails network managed by the Spartanburg Area Conservancy since 1993. The Palmetto Conservation Fund, Spartanburg County and the South Carolina Department of Transportation collaborated to restore the bridge to its circa 1928 appearance.

Families have long come to swim at Lawson's Fork Creek. The beautiful waters pull on kayakers, fly fishermen, folks with cane poles and hikers.

Within the Pacolet Historic Mill District, you'll find more than 250 Craftsman-style homes, South Carolina's largest concentration of this type of architecture. The Craftsman (also known as Arts and Crafts) architectural period reigned from 1905 to 1930. Its features included stone porch supports, numerous windows, beamed ceilings and built-in seating, shelves and cabinets. Following long and difficult shifts, these simple and economical bungalows provided respite to weary workers. Spartanburg offers a lot and makes for a great day-trip venue.

If you go:

Drive to downtown Spartanburg and take South Pine Street about four miles to Dogwood Club Road. Turn left onto Dogwood Club Road and follow one mile to Whitestone Glendale Road. Turn left onto Whitestone Glendale Road and follow a half mile to Emma Cudd Road. Bear right and park at the bridge or the flower sculpture. Steps to the right of the bridge descend to Lawson's Fork Creek. Follow the creek downstream to falls. You can also drive a quarter mile down Emma Cudd Road to a small community park (on the left) with a picnic shelter and tables. From there, follow the creek upstream to the falls, dam and bridge.

FOR MORE INFORMATION, VISIT THE LINKS BELOW:

- http://glendalesc.com/millstory.html
- http://www.sciway.net/sc-photos/spartanburg-county/glendale-mill.html

THE SOULFUL SOUTH

A two-hour drive will take you back to 1794 and some old-time religion. Drive eighty miles to the Ridgeville vicinity, and you'll find the Cypress Methodist Camp Ground, where old-time religion is alive and well. Such camps were once common throughout the South, and to see one is to step back into history. The campground continues to host annual weeklong camp meetings, a carryover from the Great Awakening in American religious life that swept through the American colonies in the 1730s and '40s.

This daytrip is a good place to find peace and quiet, a time to reflect. The Cypress Methodist Camp Ground has a beauty all its own, and it's definitely no flash in the pan. Folks have been gathering here to sing, pray and hear the gospel for 219 years. Families own the tents, and specific guidelines determine how they are passed down. It's an heirloom, a heritage.

I went and parked beneath a big oak dripping Spanish moss and walked the grounds, trying to imagine what a meeting must have been like in the old days. It had to be full of sounds, sights and sensations. Gospel songs ringing out. Maybe an old foot-pedal organ, too. Greens and sweet potatoes cooking. Lots of good food and conversation. For sure, far-flung families looked forward to a bit of a reunion. Kids played and laughed while old folks caught up.

Across the lane running alongside the campground stands a row of about a dozen privies. Lined up, they look like an old-fashioned version of the plastic portalets we see at festivals. The old wooden outhouses

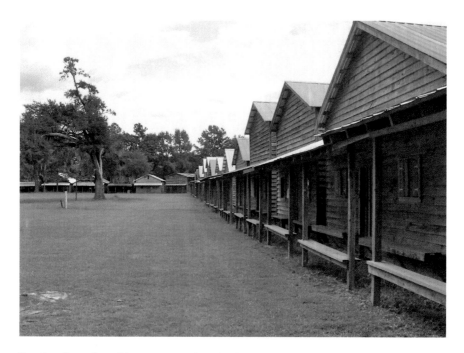

People refer to the cabins as tents, a throwback to earlier times when people stayed in canvas tents.

possess more class by far. Some were padlocked, and two had wildflowers blooming yellow in front.

The campground takes the general shape of a rectangle bordered by "tents." Calling these rough-hewn wood cabins "tents" is a carryover from the days when people slept in canvas tents. These cabins, roughly rectangular, are generally one and half stories with earthen floors. In the center of the rectangle stands the tabernacle, an open-sided wooden structure. Its pews, washed by rains blowing in, are weathered and worn smooth by many a rear end.

Other campgrounds are out there off the beaten path, but you seldom hear of these throwbacks to the days when folks would live and pray together a week at a time. That old-time religion was rustic and passionate, and it carries on. It was a time for the Lord and a time for family. More often than not, it was hot and now and then cold. The winds cut right through the walls. Sleep did not come many nights, but each morning broke with hope in the air.

"We're going to camp." Those words carry the weight of a tradition well over two hundred years old. People carry on the tradition, living in a rustic

religious way for a week once a year. They don't need plumbing, televisions or air conditioning. Just give them that old-time religion. It's good enough for them. Go see for yourself.

If you go:

The Cypress Methodist Camp Ground is located on Highway 182 in the Ridgeville vicinity. For more information and photos, visit www. nationalregister.sc.gov/dorchester/S10817718003.

THE SOUTH CAROLINA COTTON MUSEUM

Follow the cotton trail to Bishopville, and you'll come to the South Carolina Cotton Museum, which sits just across the corner from Flag Park. (More on Flag Park, which the Cotton Museum maintains, later.) The Cotton Museum will teach you all about cotton, a miraculous plant surprisingly related to okra and hibiscus.

"God gave us a wonderful commodity," said Janson Cox, the museum's executive director. Visit the museum Cox curates, and you'll learn that cotton is food, too. Commercially made cookies, potato chips and processed foods all use the seed's oil. You'll find plenty of surprises here.

Kids love the monstrously huge boll weevil, cotton's nemesis that brought destruction and hard times to the South. (Kids also love the plaster molds of Lizard Man's footprints. Be sure to see this evidence of the Pee Dee's legendary monster. Cox will tell you that Native Americans spoke of strange men with long tails roaming this region.) "Soaring" just beyond the boll weevil is a Cessna Ag Wagon, which was often used to spray fields. (Its prop actually turns!) Preserved in a vial is the last boll weevil captured in South Carolina. You can also see Whitney's Spike Gin, patented in 1794.

Blacksmiths were crucial to the growing and harvesting of cotton, and a blacksmith shop stands in the museum. Note the wagon that stands high over the shop. Wagons gave blacksmiths a model, so to speak. Farmers with broken wagon parts would point to whatever parts they needed, and the blacksmith would fire up his forge and re-create them.

Kitchen and bedroom all rolled into one—such was a simple cotton farmer's residence. (Note the bathroom by the bed.)

In reality, this big, bad boll weevil was quite small, but its negative impact on cotton was huge.

You'll see what a simple farm home was like, too. The bedroom and kitchen were in one room, and it's hard to miss the "slop" jar by the bed.

See old wooden scales that weighed cotton. The scales told the landlord how much each worker earned and how much money he'd make at the gin. See, too, the old "hit-and-miss" engine that powered farms and the life-size mule whose teeth chomp and tail swings back and forth. Created in 1942 for Tapps department store in Columbia, many children "rode" that mule.

Once your visit to the Cotton Museum is over, walk across Cedar Lane to Flag Park. There you'll see statues of a remarkable athlete. Felix Anthony "Doc" Blanchard Jr. grew up in Bishopville. Blanchard, a hard-running fullback known as "Mr. Inside" at West Point, was the first junior to win the Heisman. Three statues commemorate his legacy as a boy with dreams, a gifted athlete and a fighter pilot. The park also honors men and women in active military duty. Robert Allison, a South Carolina sculptor, created the statues.

Where can you see a Heisman winner and the history of King Cotton? At the South Carolina Cotton Museum, which some curators consider to be the country's premiere cotton museum. (A military museum is also taking shape next door.) Pay the Cotton Museum a visit, and let its five-hundred-pound cotton bales take you back to the days when backbreaking labor harvested cotton, that one-time King of the South.

If you go:

SOUTH CAROLINA COTTON MUSEUM
Bishopville, SC
121 West Cedar Lane
Monday through Saturday, 10:00 a.m. to 4:00 p.m.
803-484-4497
www.sccotton.org

WALNUT GROVE PLANTATION

Go Back to Pre-Revolutionary Times

Here's a "daycation" you can take this summer or plan for the fall—an eighty-six-mile drive to Walnut Grove Plantation near Spartanburg, a circa 1780s farm/plantation that's listed on the National Register of Historic Places.

Named for the walnut trees planted on the property by Kate Moore Barry, Walnut Grove Plantation's story begins around 1765, when Charles and Mary Moore established the plantation on a 550-acre king's land grant. Many of Walnut Grove Plantation's outbuildings from the eighteenth century still stand. Among them are a blacksmith shop, a wheat house, a barn, a meat house, a well house with dry cellar, a school and doctor's quarters. Kitchens of that era generally stood apart from the main dwelling because they were hot, prone to being smoky and, more to the point, often caught fire. Note how gourds provided useful homegrown wares such as bowls, scoops and funnels, all essential to preparing food. You'll find them more picturesque than plastic bowls.

Put Walnut Grove Plantation on your fall itinerary if you like. FestiFall, a two-day festival at the plantation, gives visitors an opportunity to see colonial-era reenactors practice crafts and trades. Watch as aptly named Ike Carpenter of Edgefield demonstrates his pioneer woodworking skills at FestiFall. In early days, men like Carpenter shaped wood into useful tools and beautiful furniture. A steady hand and an eye for detail rendered oak into functional works of art. See how Carpenter's handcrafted spoons replicate the look and feel of colonial America. Today, the indispensable wooden spoon brings a pioneering touch to modern kitchens.

Other craft artists like Greenville's Mary Alice Goetz come to FestiFall to demonstrate basket weaving. She weaves split oak strands into heirloom baskets that will bring function and beauty to generations of users. See a blacksmith work his forge, a cooper make barrels and other craftsmen demonstrate how essential goods were made.

In 1961, Thomas Moore Craig Sr. and his wife, Lena Jones Craig, descendants of the Moore family, donated Walnut Grove Plantation and eight acres to the Spartanburg County Foundation in a special trust fund. Now the public can tour and learn from this historic site. Walnut Grove Plantation chronicles how free and enslaved people settled South Carolina and other colonies. Part of its story is the fight for independence and the building of a new nation. Take a tour and see that story come alive.

If you go:

The trip takes about an hour and 20 minutes. Walnut Grove offers hourly guided tours of the site's 250-year-old buildings. Learn about colonial and Revolutionary-era history and see reenactors portray people of the time.

WALNUT GROVE PLANTATION
1200 Otts Shoals Road
Roebuck, SC 29376
864-576-6546
www.spartanburghistory.org/walnutgrove.php
Call ahead to plan group tours.

WALTERBORO'S GREEN SHIMMERING HEART

A City Sanctuary Creates a River

There are roads in Palmetto land that go nowhere near big cities. And that's not bad. One road, Highway 64, leads to Walterboro, where an ancient lane once cut a green, leafy tunnel through a swamp. Just three minutes off I-95, a town, of all places, provides a tranquil setting to contemplate a southern swamp. Had Joseph Conrad written a novel about Walterboro, he might have titled it *Heart of Greenness*, for a shimmering 842-acre swamp lives within Walterboro's city limits.

Located in the ACE Basin, the East Coast's largest estuarine preserve, the sanctuary may well provide the only braided creek swamp accessible to the public. The Ashepoo River's headwaters (the "A" in the ACE Basin) originate in the sanctuary.

The sanctuary offers many opportunities to observe wetland life. Stroll the boardwalk stretching over more than two miles of swamp. See the old Charleston–Savannah stagecoach road, where George Washington gazed out a stagecoach window "to acquire knowledge of the face of the country." At best, he made thirty-three miles a day the spring of 1791, and you can bet he saw plenty of wildlife.

As for the swamp, it consists of hardwood flats with interweaving streams. Natural wealth includes beaver, deer, fox, otter, mink, opossum, raccoons, squirrels, wildcats and wild turkey. Feathers aplenty here. Bird life includes a large, year-round population of songbirds, wading birds, ducks and raptors. The area serves as an important resting area for transient and migrating birds.

The Walterboro Wildlife Sanctuary brings history, culture, recreation and education together in a unique setting. Overland trails and boardwalks offer a chance to get some exercise, as does a bicycle path. Tying it all together is the Discovery Center, an interpretive exhibition hall that informs visitors about the important role swamps play in the Lowcountry ecosystem and the habitat they maintain for numerous flora and fauna.

It's a matter of mere steps from natural history to Walterboro's main historic district. Consider an overnight stay in this unique place where a swamp sanctuary forms a town's green heart—and remember that man needs swamps, too. They serve to cleanse our water, remove toxins from the environment and, best of all, remind us of the tremendous losses we've suffered when it comes to swamps and wetlands, once felt to be a source of diseases, thanks to the evil miasmas people believed to emanate from them.

If you go:

399 Detreville Street
Walterboro, SC 29488
843-549-2545
Open from dusk until dawn
www.walterborosc.org/walterboro-wildlife-sanctuary.aspx

WEST MAIN STREET, SPARTANBURG

Art, Books, Great Food and Handcrafted Beer

Make the journey to West Main Street in Spartanburg, and you'll find an engaging art collection, a savory restaurant, a unique bookstore and an exceptional microbrewery.

A tree-lined thoroughfare spirits you into the city's downtown district. Parking is free, and the aforementioned attractions line the same side of the street. Here's a great opportunity to appreciate the Johnson Collection at 154 West Main. Public relations coordinator Lynne Blackman describes the gallery as "a presence, not a place." The collection, which consists of over one thousand pieces, is "all fine art of the American South," said Blackman. You can see the work of native southerners, itinerant artists, Charleston Renaissance artists and others here.

"Looking back, it was always the sense of place that drew George and me to beautiful pictures—pictures that capture not only the glorious landscape of the South, but that also enliven its unique culture and dynamic history," said Susu Johnson. TJC, as it's known, focuses on African American and female artists.

At 186 West Main, you'll find the Hub City Bookshop, a revolutionary independent bookstore. Each book purchased nourishes new writers and helps launch authors into the literary world. The store shares the ground floor of the landmark Masonic temple with Little River Coffee Bar and Cakehead Bakeshop. Executive Director Betsy Teter oversees this vital literary center. She considers the store, which specializes in literary fiction and nonfiction, "an indie store for serious readers." The shop does not carry romance, how-to or travel books but, along with Hub City Press titles, stocks a sampling of everything else, including children's/YA, sports, humor, poetry, mystery, food and sci-fi. It also has sections for used books and "the best of independent presses."

George Dean Johnson Jr. and Susan (Susu) Phifer Johnson's interest in Carolina paintings blossomed into a desire to enhance the educational environment and cultural vibrancy of their hometown, state and region.

Relax at RJ Rockers and try the Son of a Peach, made with South Carolina peaches.

Enjoy lunch at 226 B West Main Street. That's where Cribbs Kitchen serves up great burgers, salads, wraps, pesto-crusted trout and more. Appetizers include tempura shrimp skewers, pork and collard green egg rolls and buttermilk fried calamari. The Classic Burger is as good as you'll get. The menu has entrées sure to please all.

At 226 A West Main Street, you'll smell the sweet fragrance of beer brewing. Solar-powered RJ Rockers Brewing Company became Spartanburg's first brewery in 1997. Owner and brewer Mark Johnsen set out on a mission to provide the Upstate with the best microbrewed beer people ever tasted. Following his service in the 1991 Gulf War, Mark was stationed in Germany, where he learned as much as possible about brewing from the experts. The good folks at RJ Rockers believe their beer makes the world a better place. They invite people to the brewery on Thursdays (5:00 p.m. to 7:00 p.m.), Fridays (5:00 p.m. to 7:00 p.m.) and Saturdays (12:00 p.m. to 4:00 p.m.). Join them for a pint.

Stroll Spartanburg's West Main and satisfy your soul's craving for art, good books, good food and good beer. It's just a ninety-five-mile, ninety-minute drive and well worth it.

If you go:

THE JOHNSON COLLECTION
154 West Main
http://thejohnsoncollection.org/tjc-gallery
Open Tuesdays and Thursdays from 11:00 a.m. to 6:00 p.m.; always open third Thursdays from 5:00 p.m. to 9:00 p.m. for Spartanburg's Art Walk.
No fee

HUB CITY BOOKSHOP
864-577-9349
http://hubcity.org/bookshop

CRIBBS KITCHEN
864-699-9669
www.cribbsonmain.com

RJ ROCKERS
864-585-BEER (2337)
www.rjrockers.com

WOODS BAY STATE PARK

Near the little town of Olanta, you'll see a landform that some folks believe was created by a meteor: Woods Bay. It's not the only bay, though. Thousands of so-called Carolina bays stipple the landscape from New Jersey to Florida. (Aerial laser technology actually confirms 1 million.) The most beautiful bays fleck North Carolina, South Carolina and Georgia. A bit like divots, most of these bays occur in the Carolinas, hence the name. We're lucky to have a state park that preserves Woods Bay, a great example of a large bay yet to be destroyed by man. Woods Bay is a fascinating place, rich with wildlife and botanical wonders.

We call places like Woods Bay "bays" because bay trees—magnolias and laurels—dominate many of these pockets. At ground level, they look like, well, swamps. Chances are you've driven by many a Carolina bay and didn't realize it. From the air, however, they are elliptical depressions oriented from northwest to southeast and parallel to each other.

Recently I went back to Woods Bay. It's remote and isolated, and you'll hear no evidence of man, save a jet from Shaw Air Force Base now and then. In the fall, if you stand still and listen, you'll hear what sounds like rain. Acorns, leaves and twigs fall continually. In spring, you'll hear water being broken by fish, frogs and turtles.

I was glad to see that Woods Bay hasn't changed much. Years ago, I helped make a film that explored the bays' origins and extolled them as wildlife oases. I often shot footage at Woods Bay. Serene and isolated—those words still describe Woods Bay. No, three words—all with equal weight—serene,

Walk the boardwalk quietly, and you'll see skinks, turtles, snakes and possibly an alligator.

Woods Bay's sand rim resembles a dusting of snow.

isolated and primeval. Once upon a time, I captured ancient creatures on 16-millimeter film. An anhinga drying its wings. A gator gliding past water lilies. A stubby cottonmouth braiding through cypress knees. Turtles sunbathing on logs. Primeval denizens. I felt like I was in 1800s Botswana.

There was a boardwalk, too, from which I filmed birds. (Woods Bay always delivered a profusion of wildlife, including osprey, carnivorous plants, wood ducks and otter.) Today, a new and far superior boardwalk will take you past sunning snakes and turtles and all types of luxuriant plant life. It's a great place to hone your wildlife photography skills.

Coming back many years later, my film days behind me, I still find Woods Bay to be as delightful as ever. As November's autumn light lit up orange cypress needles, their images danced across black waters. I, too, reflected. Woods Bay and its fellow bays are quietly doing what they've always done: controlling floods, purifying water, stockpiling carbon and giving man a place to sort out things. To that list, you can also add clean air production, sediment retention and nutrient recycling to the benefits, as well as beauty and mystery—especially mystery.

The origin of Woods Bay and other bays most likely is long-term wind and wave action that gradually shaped the bays and piled sand at their southeastern ends. Don't let that rather bland theory keep you from seeing a miraculous place. Pack a picnic and don't forget to check out the adjacent millpond. It's rich with wildlife and photo ops, too! And when you drive in, you can't help but notice the snowy-white sand rim that is a beautiful hallmark of Carolina bays.

If you go:

11020 Woods Bay Road
Olanta, SC 29114
843-659-4445
Open daily from 8:00 a.m. to sunset
www.southcarolinaparks.com/woodsbay/introduction.aspx

JUST AROUND THE CORNER

Day Trips 50 Miles or Less

A PLACE CALLED PROSPERITY

It's Equal to the Name

It's close by (just thirty-six miles), and it brings to mind Andy Griffith's Mayberry. Columned, southern homes stand at the edge of town, and live oaks shade lawns sequestered within white picket fences. Driving through its outskirts, you get the feeling Prosperity is a peaceful, happy place. "Prosperity." The name even sounds right—kind of like the title of a Norman Rockwell painting.

Chartered in 1851 as "Frog Level," such a name deserves an explanation. One legend claims an old man had one too many draws on the bottle and fell asleep by a pond. When he awoke, he thought the croaking frogs were crying, "Frog level." In 1873, at the insistence of most residents, the legislature changed the name to "Prosperity."

There's a timeless quality here—the feeling you get around stones, old trees and buildings from another era. Consider the Prosperity Drug Company on North Main Street, open since 1895. Its marble fountain counter is the real deal. No faux marble here. Along its façade and underneath it are thirteen panels of beautiful marble, their origin a mystery.

Prosperity is not hurting for international fare. Wendy Steiner's Gasthouse zur Elli has operated since 1999. She grew up in Bavaria in a town smaller than Prosperity. "In Germany," she said, "when you live in a big town, you always drive out of town into the country to a restaurant and have a good time there. When you are in a German restaurant, there is no fast food. You go in, you drink, you enjoy yourself with all the other people—then you eat, and then you drink again, and that's your weekend. That's the way it is in Germany."

You'll find a bit of Deutschland in Prosperity.

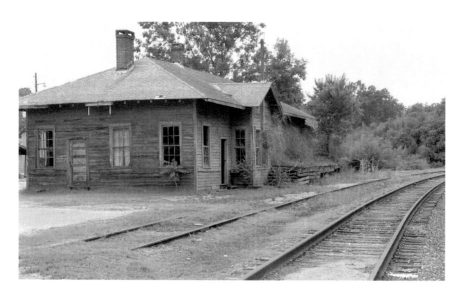

The old Southern Railway depot before it was rehabilitated.

In the past, folks in Prosperity have used "Main Street to Lake Murray" as a sort of tagline, a rallying cry for local businesses. Sure enough, Main Street leads right to Lake Murray. These days, the motto is "Prosperity, SC—Equal to the Name."

If you want to see gorgeous furniture with a past and a future, go peer through the windows of Lowell Dowd and his father, Edwin's, Dixie Heartpine Inc. If the front of their building on North Main reminds you of a weathered old southern smokehouse, well, it should. Blackened weatherboard—the real deal—fronts it. Harvested in the 1880s, the wood was anywhere from two hundred to eight hundred years old at harvest time. "That wood was here before Christopher Columbus discovered America," said Lowell. "Some of it is one thousand years old."

The Dowds scour the countryside seeking old buildings concealing longleaf pine beneath old paint and weathering. Longleaf pine was the tree of choice for America's first settlers, but today fewer than ten thousand grow wild. The Dowds carefully salvage the wood, board by board, and build custom heart pine furniture. Lowell ran his hand over a beautiful table, pointing out the original nail holes. "We don't stress the wood," he said. "Over 125 years stresses it enough."

The natural, red patina of heart pine (also called "heartwood") bestows a radiant glow to the Dowds' store, and walking amid the beautiful pieces is very much like walking back in time. Hand-hewn beams, mantels, antique chairs? They're here, and so are some interesting murals. Check out Prosperity's rehabilitated train depot less than an hour away in neighboring Newberry County.

If you go:

Take Highway 76 and enjoy the sights.
Learn more about Prosperity's history at www.prosperitysc.com/page/history.

BLACKVILLE'S HEALING SPRINGS

See the Shamrock's Ruins

In Blackville, you'll find Ray Miller's Bread-Basket, with his famous homemade bread, and Healing Springs, a longtime destination for people seeking natural remedies. Here, too, you'll find Barnwell State Park and the ruins of the Shamrock Hotel. A fifty-one-mile drive—just one hour and eight minutes—gets you there.

A Mennonite family operates Miller's Bread-Basket on Main Street. Ray Miller owns Miller's Bread-Basket, a quaint, charming place. Just look for the fellow who resembles Ernest Hemingway. They say the meatloaf is out of this world. You'll relish the wonderful greens and fried chicken. Don't forget to take your sweet tooth with you. Lil Stoltzfus, the "Pie Lady," makes German chocolate pies, Dutch shoofly pies, pecan pies, chocolate fudge pies, apple pies and others. Try the cinnamon raisin bread. Consider the entrées here Pennsylvania Dutch with a southern touch.

Just down the street stand the ruins of the old Shamrock. For years, Ray Miller has advocated restoring Blackville's one-hundred-year-old Shamrock Hotel, once a whistle stop on the old Hamburg–Charleston railroad. In its glory days, the Shamrock was a hub of activity where people played poker and pool.

The hotel is both haunting and beautiful. In its heyday, green tiles spelled out "The Shamrock" on the lobby's white ceramic tile floor near the entrance. Once a hub of activity, the old hotel crumbled into ruin, a reminder of days when people rode trains, not cars.

Close by is Blackville's Healing Springs, known as God's Acre Healing Springs. Lute Boylston deeded the springs to God in 1944. The deed states

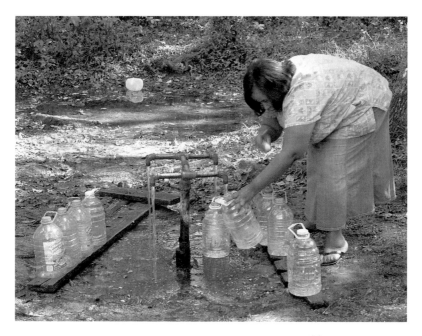

People come from near and far to load up on water from God's Acre Healing Springs.

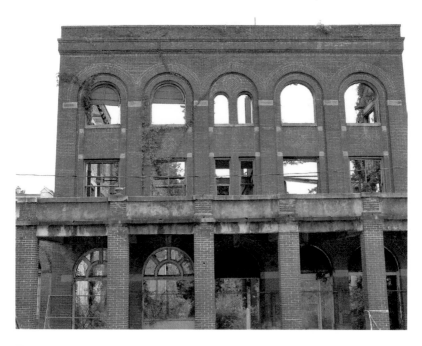

The advent of cars was the beginning of the end for the Shamrock Hotel.

that the owner of the land surrounding the springs is "God Almighty." (He's always been the owner.) A sign at the springs states, "According to tradition the Indians reverenced the water for its healing properties as a gift from the Great Spirit. They led the British wounded to their secret waters during the American Revolution, and the wounded were healed. This historical property has been deeded to God for public use. Please revere God by keeping it clean."

Gallons gush forth every minute. Take some jugs with you. Back a ways, I knew a woman who would regularly make a 120-mile round trip to the springs. Laden with many plastic milk jugs, she came home with the therapeutic spring water and swore by it.

Continue your day at Barnwell State Park. Built by the Civilian Conservation Corps during the Great Depression, this park has a reputation as a great place to fish. Feel like staying overnight? Arrange a stay at one of the park's cabins.

Blackville might be a sleepy town, but you won't go hungry, and you will find plenty to do. Check out this town in the South Carolina Heritage Corridor. And if some stubborn ailment plagues you, well, you just might find a cure at the end of your drive.

If you go:

MILLER'S BREAD-BASKET (NO CREDIT CARDS ACCEPTED)
483 Main Street
Blackville, SC 29817
803-284-3117

GOD'S ACRE HEALING SPRINGS
Blackville, SC 29817
Springs Court

BARNWELL STATE PARK
223 State Park Road
Blackville, SC 29817
803-284-2212

CONGAREE NATIONAL PARK

The Dawn of Creation

To travel back to earth's distant past, you need only make a thirty-minute, nineteen-mile drive to Congaree National Park near Hopkins. In your backyard are cypress-vaulted cathedrals that tower over black water. You can canoe or walk beneath one of earth's tallest canopies. Everything is free, and you can bring your dog.

When you arrive, park near the Harry Hampton Visitor Center. Rangers will answer your questions and help you plan your day. Check out the natural and cultural history exhibits. Watch a film on the park's history and activities.

More than 25.0 miles of hiking trails lead you into Congaree floodplain wilderness. (Colored markers keep you on the trails.) The 2.4-mile boardwalk, suspended over still water and swampland, can be walked in two hours or less. (There is limited access for dogs.) From the boardwalk, you can spot ample flora and fauna. Varying seasons bring different species. Look for cardinal flowers, salamanders, mushrooms, tree frogs and even osprey. Want a guide to explain things? Call the park to make reservations for special walks and canoe trips.

You'll find much to do all day—picnicking, fishing, kayaking and simply enjoying the beauty and serenity. Bring your own canoe or kayak, and don't be surprised if you find yourself staring upward a lot. South Carolina's last virgin forest stands as tall as any temperate deciduous forest the world over. World record–size trees take their place here among California's redwoods and Yosemite's sequoias; three-hundred-year-old loblolly pines, exceeding 15 feet in circumference and 150 feet tall, reach into the sky.

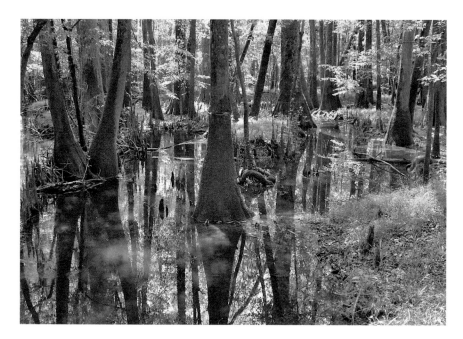

Congaree National Park's swampy terrain is what helped save its record trees from loggers.

Before saws and dams arrived, 24 million acres of bottomland beauty carpeted the East Coast. Congaree Swamp—the one bottomland refusing to go quietly in the night—saved itself, but not without a fight. In the 1890s, loggers felled some bald cypress monarchs whose water-soaked logs sunk in revenge rather than float downriver to sawmills. The frustrated loggers abandoned their quest. Only nature has touched Congaree since.

Nature set this green-variegated gem—the country's fifty-seventh national park and South Carolina's first—along the Congaree River's north bank about nineteen miles southeast of Columbia. It's the country's largest contiguous tract of old-growth bottomland hardwood forest.

While exploring the park, you'll work up an appetite. Unless you plan to drive twenty-five minutes down Bluff Road to a restaurant in Columbia, you might want to pack a picnic for eating in designated areas.

At Congaree National Park, you can take a trip back to the dawn of creation. Walk the boardwalk over the black water. Take trails deep into the primeval forest. Canoe where otters braid through cypress knees. Inhale the same rich forest scents prehistoric foragers breathed. Then let out a thankful sigh that a relic of the great forest primeval endures—just a short drive away.

If you go:

CONGAREE NATIONAL PARK
803-776-4396
Admission is free, as are the tours.
The park is open twenty-four hours a day, seven days a week.
The visitors' center is open from 9:00 a.m. to 5:00 p.m. daily (except on Thanksgiving, Christmas and New Years Day).
For directions, visit www.nps.gov/cong/index.htm.

HARBISON STATE FOREST

In the heart of the South Carolina Midlands sprawls a state forest with a deep and rich history. Bordered on one side by the Broad River, Harbison State Forest is one of the largest public green spaces inside city limits in the eastern United States. It's hard to believe Columbia is right next to the forest.

See the forest's old cabin, hike or bike its thirty-one miles of roads and trails and enjoy history itself, for this is where Catawba and Cherokee tribes found sustenance in the woods and waters of the Broad River. When European settlers arrived, an oft-used ford in the forest came to be known as "Deutsche Volk." Today, we know the area as Dutch Fork. You can walk these woods as Native Americans and European settlers did. Get close to the Broad River and see its rapids, where a rocky ridge extends across the river—visible evidence of why we call this region the fall line.

The Harbison Environmental Education Forest proper has eighteen miles of trails where you can cycle, hike, jog or walk. Be on the lookout for deer, birds and the common gray squirrel. You'll find ample trails sure to meet your level of adventure. Trail difficulties range from easy and moderate to moderately difficult and difficult.

The Harbison Environmental Education Center, a five-thousand-square-foot log building, serves as a classroom that teaches visitors about the forest. Encircling the education center, the Learning Trail hosts four outdoor classrooms where you can learn about the complexity of forest ecosystems. (The forest consists of approximately sixty-seven species of trees.)

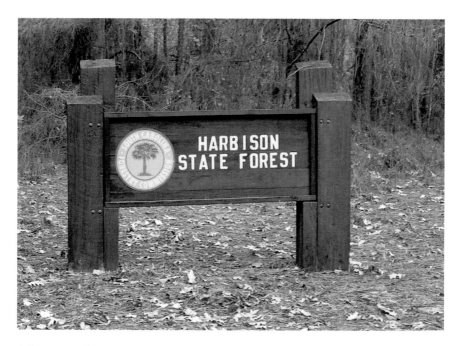

A forest sprawling 2,137 acres (one of the largest public green spaces inside city limits in the eastern United States) brings a green and wild touch to the Midlands.

You'll find plenty of reasons to take a break. After a short walk down the Discovery Trail, you'll find a pine gazebo in a meadow. Here and there are smaller picnic areas. Strike out north about a third of a mile up the trail across from the gazebo field, and you'll come to the Eagle Shelter, a great setting where traffic lights, honking horns and the crush of city life seem far, far away.

Don't overlook this area come cold weather. A winter hike offers a time when you can see farther, be free of pesky insects and not work up a sweat. Keep in mind some basic rules. Whatever you carry in pack out. (You'll find drinking water and restrooms at the picnic area.) Bicycles are allowed only on designated trails. Wear approved helmets when cycling. You can canoe here, too.

Make a day trip to a beautiful, bountiful green space. Head to Harbison State Forest and leave your worries behind.

If you go:

HARBISON STATE FOREST
5500 Broad River Road
Columbia, SC 29221
803-896-8890
www.state.sc.us/forest/refharb.htm
Parking passes are required for all visitors. Get them at fee boxes, online or at the education center.

HITE'S BAR-B-QUE

Cooked in a Pit over Hickory Coals

Pick a day when you will be starving for traditional pit-cooked barbecue and drive to Jackie Hite's Bar-B-Que just off Highway 23 in Leesville, just fifty miles away. You'll know you're in the right place when you park by the tracks and inhale the delicious aroma of woodsmoke and hogs sizzling over hickory coals. Look for wisps of smoke and the patriarch of pork, Jackie Hite, who barbecues hogs the old-fashioned, traditional way. If you park to the side of Hite's, you'll hear the chop, chop, chop of cleavers and, every now and then, the wailing horn of a Northern Suffolk train barreling by out front.

Hite burns four-foot logs of hickory in a firebox, and pitmaster Tim Hyman wears a path to the pits carrying shovels of red coals, which he spreads beneath sizzling half hogs. A picky type once asked Hite how he knew the coals were hot enough. "If them hogs ain't smoking and ain't dripping, they ain't cooking," replied Hite, who's been cooking hogs for forty-two years.

Hite's operation functions like a well-oiled machine. He's got a veteran crew that knows what it's doing. "I've had the same crew all my life. Some people just like to work," said Hite. And some folks—make that a lot of folks—just like to eat his barbecue. Inside the buffet, you'll see locals and visitors from afar. "Folks come here from Alabama to fish, and they take my barbecue back to 'Bama—Georgia, too," said Hite.

Hite takes great pride in the way he cooks pigs—a twenty-five-hour process. "Sloshing mustard sauce on hogs makes it real barbecue," he says,

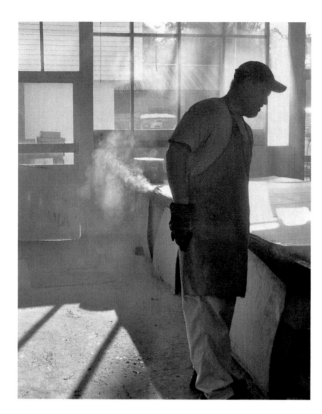

Left: Pitmaster Tim Hyman checks the heat.

Below: Q! Get it at Hite's down in South Carolina's Mustard Belt.

pulling on the bill of his Gamecock cap. (You won't catch him without that cap.) Now and then, he'll pull out a four-foot hickory stick. "[These are] used for two things," he says. "For manners in school and stirring coals in barbecue pits." Hite's a friendly fellow who talks just like he looks, and along with good food, he dispenses some of life's lessons. "I could be a cop without a gun. Folks respect me 'cause I do the right thing."

You can boil Hite's approach down to seven words: hogs, hickory, fire, smoke, sauce and hungry people. As the hogs simmer and mustard sauce rains down on them, the smoke rises to the top of the outbuilding and drifts over the community. Says Hite, "Folks drive through and say, 'Man yo place smells good!'" Every so often, they cover the simmering hogs with giant sheets of cardboard to keep the smoke in. The cardboard refuses to burn. "We don't throw that kind of heat to it," says Hite. Outside, folks queue up at 10:45 a.m., eager to get some of Hite's barbecue.

A food reviewer wrote that it's worth driving one hundred miles to eat at Hite's. Well, you only have to go fifty miles. Make the trip to Hite's. About twenty-two dollars will feed two. The buffet opens at eleven o'clock in the morning. Once you get good and full, visit Leesville's Historic College District and Batesburg's Commercial Historic District. Walk around a bit—you'll need to. And know that Jackie Hite, who served as mayor in these parts, put the hyphen between Batesburg and Leesville. "I helped bring these two towns together," he says.

If you go:

HITE'S BAR-B-QUE
467 West Church Street
Batesburg-Leesville, SC
803-532-3354

REDISCOVER THE OLD SOUTH

In the High Hills of Santee

There's an old road that makes for a great Sunday drive: S.C. Highway 261. You'll see historic sites. You'll feel you are in the mountains while at the same time feeling like you're on the coast. More than that, you'll come across the ghosts of history. A historical marker greets travelers: "Over it came Indians, pack animals laden with hides, drovers, rolled hogsheads of produce, wagoners, and stagecoaches. The armies of two wars passed over it." Some called it the King's Highway.

Highway 261 winds through the High Hills of Santee. This area is rural, isolated and heartbreakingly antebellum. The land plunges, opening up vistas of distant ridges. You think at once of the mountains. It's a curious sight to see Spanish moss in the mountains, but Highway 261 gives you massive oaks with limbs draped in Spanish moss.

You'll find enough history here to fill several good-sized books. For starters, there's the Church of the Holy Cross. This stately old church was built of rammed earth in 1850–52. In its old cemetery lies Joel Roberts Poinsett, the man who brought us the poinsettia. A ways down the road off the beaten path, you'll come across the grave of General Thomas Sumter, the "Carolina Gamecock." He earned his nickname when he killed British soldiers for burning down his house.

Those of you who recall Ken Burn's Civil War documentary will recognize the name Mary Boykin Chestnut. She grew up in Stateburg, a stone's throw from Route 261. Chestnut published her Civil War diary as a "vivid picture of a society in the throes of its life-and-death struggle."

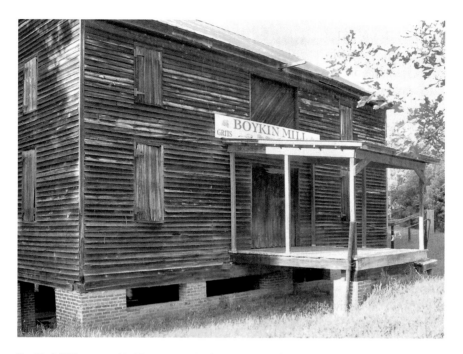

Boykin Mill long provided its community fresh-ground grits and cornmeal.

Boykin's Susan Simpson makes vibrant, sturdy brooms by hand.

Along Route 261, you'll find the hamlet of Boykin Mill Pond and its quaint old church, the Swift Creek Church. In May 1860, approximately seventy-five young people met at Boykin Mill Pond to picnic right near the church. Late that afternoon, thirty or more crowded onto a flatboat, overturning it. Close to twenty-five young people, mostly women, drowned. You'll find an old mill here, too. Boykin Mill and its one-hundred-year-old turbines preserve a time when mills provided communities with cornmeal, grits and flour. A few steps away is the Broom Place, where Susan Simpson makes sturdy, colorful brooms the old-fashioned way.

As you drive along the winding, oak-shaded lane, summon up images of a horse and buggy with men in powdered wigs and women in colonial attire. Then visualize a regiment of Confederates marching down the road, the dust rising around their feet. Imagine Mary Boykin Chestnut seeing the men and reaching for her diary as all, one by one, vanish into the eternal mists we call history. You've rediscovered the Old South, and it's just a short drive away.

If you go:

The trip to Santee is about thirty-eight miles, or about forty-eight minutes.

SWAN LAKE IRIS GARDENS

Hamilton Bland's Lovely Mistake

The accidental garden in Sumter, referred to by *Southern Living* as a "lovely mistake," developed into one of the finest botanical gardens in the United States. It came about as an accident, sure enough. In 1927, Hamilton Carr Bland, a local businessman, was developing thirty acres of swamp and landscaping his home with Japanese iris. But the iris just wouldn't cooperate. After consulting horticulturists, Bland told his gardener to dig up the bulbs and throw them in the swamp. The next spring, the iris exploded into bloom. This "lovely mistake" developed into one of the country's finest botanical gardens. It's also the country's only public park that features all swan species.

You'll see a lot of wildlife here. Black water studded by cypress knees hosts various waterfowl. The only public park in the United States to feature all eight swan species, Swan Lake Iris Gardens is also home to some of the nation's most intensive plantings of Japanese iris, which bloom yearly in mid- to late May and last until the beginning of June. The garden also boasts many other floral attractions, including colorful camellias, azaleas, day lilies and Japanese magnolias. A Braille Trail enables the sight-impaired to enjoy the sensations of the gardens.

Here, too, you'll find a butterfly garden and a striking sculpture, Grainger McKoy's *Recovery Wing*. McKoy's dramatic eighteen-foot, stainless steel sculpture represents the wing of a pintail duck in flight. McKoy notes, "This wing position is considered the weakest in bird flight, yet in the artist's eye is the position with the most beauty and grace. All of us are in recovery

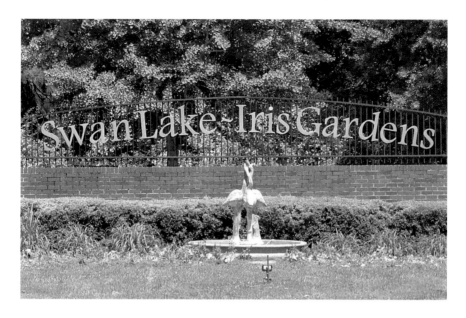

Above: You'll find all eight species of swans as well as Japanese irises in this accidental botanical gem.

Left: You can get close to a diverse array of wildlife—don't leave the camera at home!

somewhere in our lives, as is our environment, of which Swan Lake is a unique part."

You can walk trails and a boardwalk through the gardens. When you do, keep an eye out for alligators. You'll see plenty of swans and birds, but remember that feeding them is not permitted.

A curiosity is the Chocolate Garden. Established in 2009, it makes for a whimsical addition. Now warn the kids that these plants are not really chocolate. No sampling allowed! Edible plants such as chocolate cherry tomatoes, chocolate corn and chocolate mini bell peppers all have a chocolate look—but alas, the kids will be sad to know they still taste like vegetables. The Chocolate Garden also grows chocolate-covered flowers as well as chocolate-looking grasses and a chocolate Mimosa tree.

More than 250,000 people visit the Swan Lake Iris Gardens each year. Many come from afar. You, however, are close by, and you'll be glad you made the drive to this accidental garden. Perhaps you've read about the gardens in *Southern Living* and *Better Homes and Gardens*. Why not see it up close and personal?

If you go:

SWAN LAKE IRIS GARDENS
Free admission
822 West Liberty Street
Sumter, SC 29151
800-688-4748
Open daily (except holidays) from 7:30 a.m. to dusk
www.sumtersc.gov/swan-lake-iris-gardens.aspx

THE BIG MO DRIVE-IN THEATER

1950s Americana Lives On

A forty-six-mile afternoon drive to Monetta takes you to a 1950s cultural icon: the drive-in theater. Consider a "dusk trip" to the Big Mo, which begins its season on March 1. Make your way to I-20 West and take Exit 33 (S.C. Route 39). Follow S.C. 39 to Monetta (approximately seven miles) and then turn right onto U.S. 1. The drive-in is a mile down U.S. 1 on the right. If you use GPS, the physical address is 5822 Columbia Highway North, Monetta, South Carolina.

Ease along to a parking spot with a good view of the screen and get ready for a great family event. Bring your dog if it's well behaved. Bring lawn chairs, too, and sit on the grass if you like. Tune in to the movie's audio via three different frequencies and get ready for the show. The days of hanging a clunky speaker on your car window are passé.

When the lights drop, the drive-in—that one-time mecca for love-struck teenagers—flashes Hollywood idols onto the silver screen, and the aroma of grilled hot dogs and buttered popcorn fills the air. At the Big Mo, you partake of Americana. The drive-in is unique in that it is one of only two in South Carolina to survive since the heyday of drive-ins in the '50s.

The concession stand serves standard fare such as hot dogs, hamburgers and pizza. Funnel cakes and cotton candy bring a state fair feel to the evening. Popcorn's a given, as are soft drinks. Prices are very good—nothing like the big fees multiplex theaters charge. (You can't bring your own food, and there's no alcohol.)

Going to the Big Mo is like driving back in time. It's the 1950s all over again.

When Richard and Lisa Boaz opened the Big Mo on March 26, 1999, they saved a cultural icon from junkyard duty. Since the opening night screening of *The Wizard of Oz*, some sixty thousand cars have since rolled in for family fun and a return to the '50s. Here's your chance to add to the total. Just get there an hour early because people get turned away when tickets sell out. During inclement weather, the show goes on. Go when peach trees are abloom for a touch of Palmetto State beauty.

Frequent patrons get Stargazer cards for a ten-dollar credit, and it's not just marketing. The Monetta heavens, free of big-city light pollution, sparkle with celestial treats. One night, a total lunar eclipse occurred, and as Richard Boaz recalls, "One year, Mars put on a fantastic show."

An evening at the Big Mo is quite a treat. Visit the Big Mo's website and see what's coming soon. Gates open one and a half to two hours before show time. Rediscover what it's like to be seventeen again at a '50s icon in peach country.

If you go:

Admission (cash only) is eight dollars for adults (twelve and over), four dollars kids (four to eleven) and free for children under three. Gates open at 6:30 p.m., and the show starts around 8:15 p.m.
Open Friday, Saturday and Sunday nights
803-685-7949
www.thebigmo.com

THE SALUDA THEATER

Where History Will Surprise You

For many years, I drove down Highway 378 to my family home in Georgia. The journey took me through downtown Saluda, where I noticed a handsome old theater, the Saluda Theater. I didn't know much about it, but that changed in 1987 when I was working on a book for the University of South Carolina Press. When researching and writing *South Carolina: A Timeless Journey*, I wrote a chapter entitled "Highway 378," in which I covered the Saluda Theater. What a great history this theater owns. Drive forty-eight miles west, and you can see the striking theater and its colorful sign.

The theater was built in 1936. Back when I interviewed Mary Parkman, then-executive director of the Saluda County Historical Society, she said the theater opened with Shirley Temple's *Susanna of the Mounties*. Over the years, the theater hosted Lash Larue, the whip-wielding cowboy, and other notables. When cable TV and the video rental explosion hit, the old theater's days were numbered. It closed in 1981 after a forty-five-year run and gathered dust.

It was a good day in 1987 when Saluda County bought the theater and donated it to the local historical society. Renovations followed, and in August 1990, ABC-TV used the theater as the set for a scene in *And Justice for All*.

Back in its heyday, two old arc projectors that burned carbon rods stood side by side in back of the balcony. Those old projectors put out a ton of heat, and fire was a possibility. The small projection booth where they stood had two trapdoors held open by cotton strings that ran across the

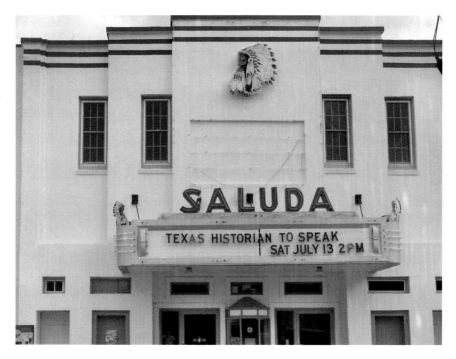

None other than Lash Larue, "King of the Bullwhip," performed here.

lens housing. If the projectors overheated, the strings caught fire, burned in two and the trapdoors slammed shut, shutting off the supply of air, a rudimentary safety strategy.

Today, the theater is on the National Register of Historic Places. If you make the trip to see it, you will see that it looks much like it did in 1936. Its Art Deco design supports the fact that it was built in a time when precise and boldly delineated geometric shapes and strong colors dominated architecture in small towns. Few theaters like the Saluda Theater exist in the United States today. Appropriately, a museum stands adjacent to the theater.

Native American (I prefer Indian) history is strong in Saluda County. When you go, be sure to check out the mural across Highway 378 that depicts Old Hop and other Cherokee chiefs ceding their territory to Governor Glen on July 2, 1755. Saluda County also has ties to the Alamo. Native sons William Barrett Travis and James Butler Bonham were at the Alamo, where both died in the Texas Revolution. Locals like to say, "Saluda County is where Texas began."

Plan a drive over to Saluda and ask about other historic sites such as "Flat Grove" and the Marsh-Johnson House.

If you go:

The theater is adjacent to the courthouse at 107 Law Range.
Learn more about the Saluda Theater at http://saludacountyhistoricalsociety.
org/saluda-theater/12-saluda-theater.html.

WELLS JAPANESE GARDEN

A Touch of the Land of the Rising Sun

Bliss, beauty and botanical gems featuring a touch of Asia—they're closer than you think. An easy forty-two-mile drive to Newberry transports you to the Land of the Rising Sun, where Wells Japanese Garden, a Newberry landmark, brings a delightful touch of the Orient to the Midlands. You'll find the gardens on Lindsay Street behind city hall.

Spring is a great time to walk trails and enjoy water features and exotic flora. The Japanese perfected the art of relaxing, and you can thank W. Fulmer Wells, an architecture graduate, for designing Newberry's Japanese garden in 1930. The young Newberry resident studied architecture in California, where he visited a Japanese tea garden at San Francisco's Golden Gate Park. Legend has it that Newberry's garden took root there. His father, W. Fulmer Wells Sr., built the garden. We can rightfully describe this garden as a Japanese American garden. While its design is Japanese, it was built using local materials. The Wells family donated the garden to the city of Newberry in 1970. Today, it is a city park—but not just any park. It is a place of serenity and reflection.

Peace and beauty are yours when you enter the garden through a torii gate, a traditional Japanese-style gate often found at temple entrances. Torii translates to "where birds reside." Torii, traditionally, are painted red. You'll find other charming Japanese architectural elements: a temple, a moon bridge and teahouse, all of which frame and overlook two small ponds. The posts of the tea house, incidentally, originally supported the balcony of the Newberry Opera House. The moon bridge spans a small creek that flows through this unique garden. It's tranquil.

Anyone who loves gardens and gardening will appreciate the Egyptian lotus, Japanese iris, water lilies, crepe myrtles, dogwood and cypress. Concrete bridges, executed in a Japanese design, span the ponds. Of particular interest are cinnamon ferns that flaunt "cinnamon sticks." Large clumps of cinnamon ferns grow in the park's damp woods and creek banks. Note the clusters of sori, which make fern-producing spores. But this is just one such plant you can see at this surprising Oriental oasis maintained by the Newberry Council of Garden Clubs.

You'll find Wells Japanese Garden in Newberry among other attractions that include the Newberry Opera House, antique shops, nearby Carter and Holmes Orchids and a range of restaurants sure to please your and your fellow travelers' tastes. Top your day trip off with another Japanese treat—green tea. It's good for you, just as your day at Wells Japanese Garden will be.

If you go:

No admission fee
Open daily from 7:00 a.m. to 7:00 p.m.
No facilities
803-321-1015
www.visitnewberrysc.com/area-attractions/wells-japanese-garden

BIBLIOGRAPHY

MapQuest provided estimates of distance and time to venues. In addition to trips I made to venues, the following resources provided information.

Abbeville County. http://www.abbevillecountysc.com.

AngelOakTree.org. "Angel Oak Tree." http://www.angeloaktree.org/history.htm.

Audubon.org. "Beidler Forest." http://beidlerforest.audubon.org.

Audubon South Carolina. "Audubon Center & Sanctuary at the Francis Beidler Forest." http://sc.audubon.org/audubon-center-sanctuary-francis-beidler-forest.

Blackman, Lynne (The Johnson Collection). Interview with the author.

Brewer, M. Karen. "Step into the Past at Collins Ole Town." *Sandlapper* (Winter 2004–05). http://www.knowitall.org/sandlapper/Winter-2004/Completed%20PDFs/57-58-Collins-Ole-Towne.pdf.

BritishBattles.com. "The Battle of Cowpens." http://www.britishbattles.com/battle-cowpens.htm.

Brookgreen Gardens. http://www.brookgreen.org.

Burt-Stark Mansion. http://www.burt-stark.com.

Carolana.com. "A History of New Bordeaux, South Carolina." http://www.carolana.com/SC/Towns/New_Bordeaux_SC.html.

Central Heritage Society. "Collins Ole Town." http://www.centralheritage.org/town.htm.

Charleston Area Convention and Visitors Bureau. "See Why They Call Charleston the 'Holy City.'" http://www.charlestoncvb.com/visitors/tripplanner/what_to_see_do~3/attractions~31/historic_houses_of_worship~47.

Charleston County Public Library. "The Sweetgrass Basket Tradition." http://www.ccpl.org/content.asp?id=15732&action=detail&catID=6045.

Charleston Tea Plantation. https://www.charlestonteaplantation.com.

Church of the Holy Cross. http://www.holycrossstateburg.com.

City of Aiken. https://www.cityofaikensc.gov.

City of Charleston. http://www.charleston-sc.gov.

City of Folly Beach. http://www.cityoffollybeach.com.

City of Georgetown. "History of Georgetown." http://www.cogsc.com/history/history.cfm.

City of Hartsville. http://hartsvillesc.gov.

City of Newberry. "Wells Japanese Garden." http://www.visitnewberrysc.com/area-attractions/wells-japanese-garden.

City of Sumter. "Swan Lake Iris Gardens." http://www.sumtersc.gov/swan-lake-iris-gardens.aspx.

City of Walterboro. "Walterboro Wildlife Sanctuary." http://www.walterborosc.org/walterboro-wildlife-sanctuary.aspx.

Cox, Janson. Interview with author.

Culture and Heritage Museums. "Historic Brattonsville." http://chmuseums.org/brattonsville.

Dave the Slave. http://www.davetheslave.org.

Dehond, Trish. Interview with the author.

Depew, Henry (RJ Rockers). Interview with the author.

Discover South Carolina. "Campbell's Covered Bridge." http://www.discoversouthcarolina.com/products/1624.aspx.

———. "Dorn Mill Center for History & Art." http://www.discoversouthcarolina.com/products/2377.aspx.

———. "Swan Lake Iris Gardens." http://www.discoversouthcarolina.com/products/347.

Eastern SC Heritage Region. "SC Tobacco Museum." http://easternscheritage.com/sc_tobacco_museum.html.

Friends of Fort Fremont Historical Park. http://www.fortfremont.org.

Friends of Harbison State Forest. http://www.friendsofhsf.org.

Greenville County Parks, Recreation and Tourism. "Campbell's Covered Bridge." http://greenvillerec.com/parks/campbells-covered-bridge.

Hembree, Michael, and Paul Crocker. *Glendale: A Pictorial History*. N.p.: self-published, 1999.

Hite, Jackie. Interviews with the author.

JimHarrison.com. "The Gallery." http://jimharrison.com/thegallery.

Kalmia Gardens. http://www.kalmiagardens.org.

Mansfield Plantation. http://www.mansfieldplantation.com.

Master Gardeners of York County. "Glencairn Gardens." http://glencairn. yorkmg.org.

McAden, Marie. "Area Near Little River Blueway Filled with History, Exploration." South Carolina Insider. http://www.discoversouthcarolina. com/Insider/outdoor/Blog/5734.

McKoy, Grainger. Interviews with the author.

Monetta Drive-In Theatre. http://www.thebigmo.com.

National Park Service. "Congaree National Park." http://www.nps.gov/ cong/index.htm.

———. "Cowpens National Battlefield." http://www.nps.gov/cowp/index.htm.

National Parks Conservation Association. "Congaree National Park." http://www.npca.org/parks/congaree-national-park.html.

National Register of Historic Places. "Cypress Methodist Campt Ground, Dorchester County." http://www.nationalregister.sc.gov/dorchester/ S10817718003.

———. "Dorn's Flour and Grist Mill, McCormick County." http://www. nationalregister.sc.gov/mccormick/S10817733003.

———. "Saluda Theatre, Saluda County." http://www.nationalregister. sc.gov/saluda/S10817741006.

———. "Spann Methodist Church and Cemetery, Saluda County." http:// www.nationalregister.sc.gov/saluda/S10817741007/.

———. "Stateburg Historic District, Sumter County." http://www. nationalregister.sc.gov/sumter/S10817743022.

———. "Wells Japanese Garden, Newberry County." http://www.nationalregister.sc.gov/newberry/S10817736022.

Nature Adventure Outfitters. http://www.kayakcharlestonsc.com.

The Nature Conservancy. "Francis Beidler Forest in Four Holes Swamp." http://www.nature.org/ourinitiatives/regions/northamerica/unitedstates/southcarolina/placesweprotect/francis-beidler-forest.xml.

OconeeCountry.com. "Oconee Station State Historic Site." http://www.oconeecountry.com/oconeestation.html.

Petersen, Bo. "Nothing Can Stop Camp Meetings." *Charleston Post and Courier*, October 10, 2009. www.postandcourier.com/article/20091010/PC1602/310109949.

Philip Simmons Foundation. "About Philip Simmons." http://www.philipsimmons.us/aboutsimmons.html.

Poland, Tom. "Down Lowcountry Way." *Sandlapper*, Summer 2006.

———. "Notes from the Road." *Sandlapper*, Spring 2010.

Poland, Tom, and Phil Sawyer. *Save the Last Dance for Me: A Love Story of the Shag and the Society of Stranders*. Columbia: University of South Carolina Press, 2012.

Poland, Tom, and Robert Clark. *Reflections of South Carolina*. Vol. 2. Columbia: University of South Carolina Press, 2014.

Roadside America. "God's Acre Healing Springs." http://www.roadsideamerica.com/story/12456.

Saluda County Historical Society. "The Saluda Theatre." http://saludacountyhistoricalsociety.org/saluda-theater/12-saluda-theater.html.

Sarata, Phil. "The 'Other Coast': South Carolina's Best-Kept Secret." http://www.discoversouthcarolina.com/files/smiles-pdfs/TheOtherCoast.pdf.

Savannah River Ecology Laboratory. http://srel.uga.edu.

Savannah River Site. http://www.srs.gov/general/srs-home.html.

SCGreatOutdoors.com. "Glencairn Garden." http://www.scgreatoutdoors. com/park-glencairn.html.

———. "God's Acre Healing Springs." http://www.scgreatoutdoors.com/ park-godsacrehealingsprings.html.

———. "Great Swamp Sanctuary." http://scgreatoutdoors.com/park-greatswampsanctuary.html.

———. "Parson's Mountain Recreation Area." http://www.scgreatoutdoors. com/park-parsons.html.

SCIWAY. "Dave the Potter—Pottersville, Edgefield County, South Carolina." http://www.sciway.net/afam/dave-slave-potter.html.

———. "Fort Fremont—Lands End, St. Helena Island, South Carolina." http://www.sciway.net/hist/fort-fremont-st-helena-island.html.

———. "God's Acre Healing Springs—Blackville, South Carolina." http:// www.sciway.net/sc-photos/barnwell-county/healing-springs.html.

———. "New Bordeaux Worship Site—McCormick, South Carolina." http://www.sciway.net/sc-photos/mccormick-county/new-bordeaux-worship-site.html.

———. "Prosperity, South Carolina." http://www.sciway.net/city/ prosperity.html.

———. "Saluda Theatre—Saluda, South Carolina." http://www.sciway. net/sc-photos/saluda-county/saluda-theatre.html.

SCTrails.net. "Parson's Mountain Tower and Lake." http://www.sctrails. net/trails/alltrails/hiking/Midlands/ParsonsLake.html.

South Carolina Cotton Museum. http://www.sccotton.org.

South Carolina Department of Natural Resources. "Sassafras Mountain Improvement Project Begins atop Roof of South Carolina." http://www.dnr.sc.gov/sassafrasmountain.html.

———. "Walhalla State Fish Hatchery." http://hatcheries.dnr.sc.gov/walhalla/about.html.

———. "Woods Bay Heritage Preserve." https://www.dnr.sc.gov/mlands/managedland?p_id=49.

South Carolina Forestry Commission. "Harbison State Forest." http://www.state.sc.us/forest/refharb.htm.

———. "Harbison State Forest Trail Guide." http://www.state.sc.us/forest/refhartg.htm.

South Carolina National Heritage Corridor. "Freshwater Coast." http://www.scnhc.org/location/freshwater-coast.

South Carolina Plantations. "Walnut Grove Plantation—Roebuck—Spartanburg County." http://www.south-carolina-plantations.com/spartanburg/walnut-grove.html.

South Carolina State Parks. "Caesars Head State Park." http://www.southcarolinaparks.com/caesarshead/introduction.aspx.

———. "Landsford Canal State Park." http://www.southcarolinaparks.com/landsfordcanal/introduction.aspx.

———. "Mountains & Waterfalls." http://www.southcarolinaparks.com/things-to-do/mountains-waterfalls.

———. "Oconee Station State Historic Site." http://www.southcarolinaparks.com/oconeestation/introduction.aspx.

———. "Woods Bay State Park." http://www.southcarolinaparks.com/woodsbay/introduction.aspx.

South Carolina Tobacco Museum. http://www.mullinssc.us/ sctobaccomuseumindex.html.

Spartanburg County Historical Association. "Walnut Grove Plantation." http://www.spartanburghistory.org/walnut-grove-plantation.

Teter, Betsy (Hub City Bookstore). Interview with the author.

Town of Cowpens. http://mycowpensgov.com.

Town of Edgefield. http://www.exploreedgefield.com.

Town of McCormick. http://www.townofmccormicksc.org.

Town of Prosperity. http://www.prosperitysc.com.

University of South Carolina–Lancaster. "Native American Studies Center." http://usclancaster.sc.edu/nas/index.html.

U.S. Department of Agriculture–Forest Service. "Parsons Mountain OHV Trail." http://www.fs.usda.gov/recarea/scnfs/recarea/?recid=47213.

U.S. Department of Veterans Affairs. "Beaufort National Cemetery." http:// www.cem.va.gov/cems/nchp/beaufort.asp.

U.S. Fish and Wildlife Service. "Cape Romain National Wildlife Refuge." http://www.fws.gov/caperomain/.

VisitAikenSC.com. "Hopelands Gardens." http://www.visitaikensc.com/ whattodo/detail/hopelands_gardens.

VisitPickensCounty.com. "Sassafras Mountain—Highest Point in SC." http://www.visitpickenscounty.com/vendor/124/sassafras-mountain-highest-point-in-sc/.

Wikipedia. "Abbeville, South Carolina." http://en.wikipedia.org/wiki/ Abbeville,_South_Carolina.

———. "Aiken, South Carolina." http://en.wikipedia.org/wiki/Aiken,_South_Carolina.

———. "Angel Oak." http://en.wikipedia.org/wiki/Angel_Oak.

———. "Beaufort National Cemetery." http://en.wikipedia.org/wiki/Beaufort_National_Cemetery.

———. "Brattonsville Historic District." http://en.wikipedia.org/wiki/Brattonsville_Historic_District.

———. "Brookgreen Gardens." http://en.wikipedia.org/wiki/Brookgreen_Gardens.

———. "Chattooga River." http://en.wikipedia.org/wiki/Chattooga_River.

———. "Chattooga River Fatalities and Near Fatalities Since 1970, Compiled by U.S Forest Service."

———. "Congaree National Park." http://en.wikipedia.org/wiki/Congaree_National_Park.

———. "Cypress Methodist Camp Ground." http://en.wikipedia.org/wiki/Cypress_Methodist_Camp_Ground.

———. "Edgefield, South Carolina." http://en.wikipedia.org/wiki/Edgefield,_South_Carolina.

———. "Ellenton, South Carolina." http://en.wikipedia.org/wiki/Ellenton,_South_Carolina.

———. "Folly Beach, South Carolina." http://en.wikipedia.org/wiki/Folly_Beach,_South_Carolina.

———. "Fort Fremont." http://en.wikipedia.org/wiki/Fort_Fremont.

———. "Four Hole Swamp." http://en.wikipedia.org/wiki/Four_Hole_Swamp.

———. "Prosperity, South Carolina." http://en.wikipedia.org/wiki/Prosperity,_South_Carolina.

———. "Sassafras Mountain." http://en.wikipedia.org/wiki/Sassafras_Mountain.

———. "Savannah River Site." http://en.wikipedia.org/wiki/Savannah_River_Site.

———. "Walnut Grove Plantation." http://en.wikipedia.org/wiki/Walnut_Grove_Plantation.

———. "Wells Japanese Garden." http://en.wikipedia.org/wiki/Wells_Japanese_Garden.

———. "The Willcox." http://en.wikipedia.org/wiki/The_Willcox.

The Willcox. http://www.thewillcox.com.

ABOUT THE AUTHOR

A southern writer, Tom Poland's work has appeared in magazines throughout the South. The University of South Carolina Press published his book *Save the Last Dance for Me*, as well as *Reflections of South Carolina* and *Reflections of South Carolina*, Volume 2. *Georgialina: A Southland* is forthcoming from the USC Press. He is one of the writers featured in the anthology *State of the Heart: South Carolina Writers on the Places They Love*, for which Pat Conroy wrote the foreword. Swamp Gravy, the community theater in Colquitt, Georgia, that is home to Georgia's Official Folk Life Drama, staged *Solid Ground*, his play.

Courtesy of Robert C. Clark.

For six years, he worked as a scriptwriter and cinematographer along the South Carolina Lowcountry and its barrier islands. That experience led to his novel, *Forbidden Island*.

He taught for nineteen years as an adjunct professor in journalism at the University of South Carolina's School of Journalism and Mass Communications. He writes weekly columns for newspapers and journals in Georgia and South Carolina about the South and its people, traditions, lifestyle and changing culture.

He earned a bachelor's degree in journalism and a master's in media from the University of Georgia. Originally from Lincolnton, Georgia, he now lives in Columbia, South Carolina.